IMAGES
of America

STORY LAND

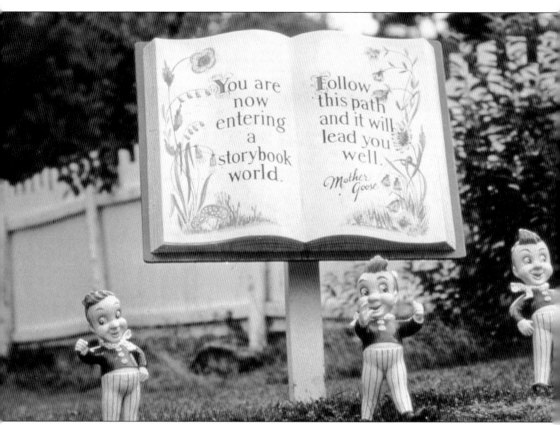

This greeting from Mother Goose has been just inside the entrance to Story Land since the opening of the park and remains today. Guests originally followed a single pathway in a counterclockwise direction around the park and finished out front at the exit. The three figurines shown in this early-1960s photograph have long since departed, even though the greeting has held true for more than a half-century. (Courtesy Story Land.)

ON THE COVER: From the porch of her new hilltop castle, Cinderella admires her realm and the Presidential Range of the White Mountain National Forest in the background. Just opened in this 1957 photograph, for the park's fourth season, Cinderella's Castle and Pumpkin Coach ride were the main features of Story Land's first major expansion. Shown here, Jackie Hayward was the first to portray the popular princess. (Courtesy Story Land.)

IMAGES of America
STORY LAND

Jim Miller

Copyright © 2010 by Jim Miller
ISBN 978-0-7385-7303-8

Published by Arcadia Publishing
Charleston SC, Chicago IL, Portsmouth NH, San Francisco CA

Printed in the United States of America

Library of Congress Control Number: 2009940544

For all general information contact Arcadia Publishing at:
Telephone 843-853-2070
Fax 843-853-0044
E-mail sales@arcadiapublishing.com
For customer service and orders:
Toll-Free 1-888-313-2665

Visit us on the Internet at www.arcadiapublishing.com

*To Mary, delicious dinner; to Georgiana and Carter,
keep having fun and choosing to be happy, always;
and to Story Land, thanks for the memories.*

Contents

Acknowledgments		6
Introduction		7
1.	Nobody Expected That Crazy Idea to Survive	9
2.	Royalty and Resiliency Even in Recession	27
3.	Safe, Smooth, Smiling, Spotless Service	51
4.	Involv-aroundings of Historic Proportions	71
5.	The Pursuit of the Unique Factor	89
6.	A Product Taken Home in the Heart	109

Acknowledgments

Just as the building and smooth operation of Story Land has been a tremendous team effort over the years, so too has been the compilation of this book. My deepest gratitude is extended to all of the staff at Story Land who encouraged this production and shared both their enthusiasm and their expertise.

Easy access to photographs, maps, brochures, postcards, and other park archival materials, as well as steady support and insightful stories, was provided by Jack Mahany. Longtime cast members Curtis Gordon, Robert "Grub" Grant, Christopher Marchioni, Pamela Gralenski, Robert Marquis, and Leslie King—with combined experience at Story Land of approximately 200 years—provided many memories and details through countless informal discussions to help make the text informative.

Members of the Morrell family have been instrumental in the development of this book. The late Stoney Morrell nurtured a creative and energizing work environment and suggested that someday the history of Story Land and what made it successful be told, sharing thoughts of not only himself and his father but also of other longtime employees. His sister, Nancy Morrell, grew up with Story Land and shared many insights into the early development of the park, which seemed to become the third sibling in their childhood household. The Morrells' cousin Robert Owen, their aunt Marion Owen, and their uncle Nathan Morrell provided many of their own remembrances of Story Land and its adjacent sister attraction for three decades, Heritage-NH.

Thank you to the editorial staff of Arcadia Publishing for including Story Land in the Images of America series. Appreciation also is extended to the stewards of the park as this book is produced, Festival Fun Parks, for allowing this effort to go forward.

The Story Land archival photographs appearing on these pages are the work of a series of terrific local photographers associated with or employed by the park over the years, including among them Robert Duncan, Richard Smith, Eric Sanford, Joseph Novick, Richard Hamilton, Robert Grant, David Moreton, Bonnie Taylor, and Jamie Gemmiti. All of the images in this book come from the Story Land archives, and they appear on these pages without individual credits.

INTRODUCTION

The background behind Story Land, a fantasy-based children's theme park, features several elements of a good fairy tale. A young man is sent far from home to perform noble work in service of others under adverse circumstances. He faces an uncertain future in providing for his wife and young daughter. A serendipitous meeting with a stranger in a foreign land provides inspiration. After returning home, years of hard work, persistence, and imagination lead to the creation of a land of enchantment enjoyed by generations of families for miles around.

The young man was Robert S. (Bob) Morrell. Originally from Manchester, New Hampshire, he had grown up in North Conway since the age of 10. After serving in the army's 10th Mountain Division ski troops during World War II, he returned to his home in the White Mountains of New Hampshire. There he and his wife, Ruth, started a family with the birth of their daughter, Nancy, and started a business with the opening of their Eastern Slope Ice Cream Company. In 1950, Bob was called back to serve with the army's Quartermaster Corps during the Korean War and was stationed in Germany for two years.

While serving overseas, and without an idea of an alternative occupation if he returned home safely again, Bob and Ruth decided to sell their small ice cream business. Dairyman Shumway Marshall purchased it, and the Marshall family operated the greatly expanded enterprise locally until 2010 under the banner of Abbott's Premium Ice Creams.

On furloughs in Germany, Bob and Ruth Morrell toured historic sites. In 1952, they met Frau Edith Von Arps from Nuremberg, renowned toy capital of the world. A skilled toymaker whose dolls are well known amongst today's collectors, she had lost her family in World War II and was struggling to survive by peddling handmade creations. The Morrells purchased a set of her dolls depicting familiar storybook characters, and she suggested they consider building a storybook village when they returned to the United States. Frau Von Arps thought it could be a way for the young couple to earn a living and could provide an outlet for her to sell more dolls.

Back home in the White Mountains, the Morrells initially wanted to build a Bavarian village to duplicate scenery they had found appealing overseas, but they quickly discovered the plans they envisioned were well beyond their financial means. Instead, they decided to see if they could actually create a family-oriented business based on children's stories.

It was 1953 and theme parks were not yet common; Disneyland did not open until 1955. The amusement parks and picnic grounds that had existed for decades were primarily built by transportation companies to sell more trolley tickets, or by other large corporations to benefit their employees. There was no model for a themed attraction based in a rural area with some seasonal tourist traffic. However, the children of the Great Depression and veterans of the Great War were maturing into parents during growing prosperity and peacetime, and families were beginning to visit tourist regions in increasing numbers in their spacious new station wagons.

Entrepreneurs in attractive rural areas worked independently and with local help to create new diversions for growing numbers of visitors. At about the same time, in the mid-1950s, small children's

parks themed around central characters such as Santa Claus and Mother Goose sprang up in New York's Adirondacks region and in New Hampshire's White Mountains, among other places.

Bob and Ruth Morrell opened Story Town in Glen, New Hampshire, in 1954. The park was little more than a gravel footpath on hilly terrain with a handful of colorful small buildings representing nursery rhymes and storybook settings. Costumed actors played the parts of Mother Goose and Heidi's Grandfather, while live animals took on the roles of famous nursery rhyme pigs, goats, sheep, and rabbits. The admission fee was 85¢, with children under 12 years old admitted for free. At the end of their first season, the Morrells changed the name of their park to Story Land to avoid confusion and legal wrangling with the new Storytown U.S.A. that Charles (Charley) Wood had opened that same summer near Glen Falls, New York.

Story Land's first amusement ride was Freddy the Fire Truck—an actual Maxim Pumper fire engine manufactured in 1923 in Middleboro, Massachusetts, and designated for a scrap auction about 30 years later by the Hillsboro, New Hampshire, fire department. For 15¢ per child and 25¢ per adult in the mid-1950s, Freddy and a driver took guests for a spin through a wooded area that was later developed into the Antique Cars ride and part of the Story Land parking lot.

In 1957, the park's fourth season featured the addition of Cinderella's Castle and her Pumpkin Coach, a ride built locally and pulled by live ponies. A wood-fired miniature steam train was added in 1959 and was later replaced by a higher-capacity, gasoline-fueled CP Huntington model. By the early 1960s, Story Land had established a pattern of continual reinvestment of profits into the development of the park and earned a reputation as a clean and caring environment where families with young children could meet familiar characters and enjoy new surprises year after year.

Throughout its first half-century and beyond, Story Land remained true to its 1950s children's theme park roots, resisting any temptation to incorporate thrill rides, arcades, a proliferation of carnival games, or commercial sponsorships. The more than 20 amusement rides today serve to complement rather than overwhelm the storybook-themed playgrounds, live and animated stage shows, costumed characters and live animals, manicured grounds and gardens, gift shops, and refreshment stands. The rides are all family oriented and sized for parents and children to share together; there are no "kiddie rides" that exclude guests over a specified height, and the few minimum height requirements are those for the safety of infants and toddlers.

Story Land operated as an independent small business owned by two generations of the Morrell family for over 53 years, through June 2007. Bob and Ruth Morrell each worked at the park throughout the rest of their lives, Ruth until 1990 and Bob until 1998. Their son R. Stoning (Stoney) Morrell Jr. presided over the business from the early 1980s until his death in late 2006. His sister, Nancy Morrell, helped him transition the park for ownership outside of the family between 2005 and 2007.

The Kennywood Entertainment Company of West Mifflin, Pennsylvania, was selected to purchase the park when terminal illness forced a sale by the second generation of the Morrell family. The ownership transfer was completed by July 2007. Kennywood was at the time a family owned, traditional park operator with complementary values and deep roots in the amusement business dating back over 100 years, and it had resources to acquire Story Land without financially burdening the company.

Parques Reunidos of Madrid, Spain, purchased the Kennywood Entertainment Company, including the just-acquired Story Land and its adoptive new family of amusement parks—Kennywood, Idlewild, and Lake Compounce, among other business operations—in June 2008. Their attractions operate under the banners of Festival Fun Parks and Palace Entertainment.

One

NOBODY EXPECTED THAT CRAZY IDEA TO SURVIVE

In Germany in 1951–1952 during a second tour in the U.S. Army, Robert S. (Bob) Morrell sold the family ice cream company and considered new business concepts to try after returning home to New Hampshire's White Mountains. However, he and his wife, Ruth, with young daughter Nancy, soon discovered that North Conway's commercial real estate in 1953 was priced beyond their means.

They found a relative bargain just north on NH Route 16 in Glen—about 100 wooded acres of hills, boulders, and mounds of sawdust formerly operated as Harmon's sawmill, a parcel the owner termed too poor for pasture. It cost the Morrells half their $5,000 total savings. They combined the rest with small loans and credit from local contractors, and long hours of manual labor, to create a park dedicated to imagination and simple childhood joys.

The inspiration behind the business was a storybook doll collection purchased while overseas. Banks declined to back the untested concept, reasoning the Three Bears' House was inadequate collateral. The one small bank loan approved was arranged in Manchester and secured by stocks rather than park interests. Established businessmen warned the market was too small and a focus on young children too limiting.

Story Town opened in 1954 and was renamed Story Land the following year. Bob Morrell worked full time each winter through 1961 at the Carroll Reed Ski Shops to help generate income for their fledgling summer business and young family. There, even mentor Carroll Reed told the couple they would likely lose their shirts on that crazy idea. Still, early results were encouraging enough to keep the Morrells investing all their earnings and free time into growing the park.

Emboldened by positive feedback from guests and an increase in visitors during the first couple of seasons, they dedicated much of 1956 to clearing land and gathering items for a planned expansion. The economy was good, guests were happy, and the Morrells were optimistic about the future of Story Land. They looked forward to aggressive growth for the business through the rest of the 1950s.

Motorists traveling NH Route 16 in Glen, New Hampshire, in fall 1953 saw only "a wide spot in the road," as Bob Morrell used to say, as this former sawmill site began its transformation into a children's theme park. This northerly view from what became Story Land's parking lot includes snow-covered Mount Washington at upper left, above Route 16.

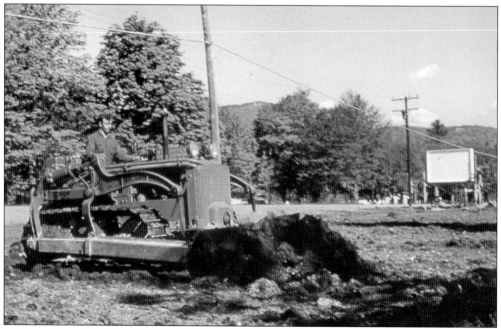

In the spring of 1954, contractor Whit Duprey leveled the gravel for the parking lot as the front sign took shape in the background. He and other local contractors worked on handshake agreements with Bob and Ruth Morrell to help clear land and get the park built and open, deferring compensation until the summer season created some cash flow.

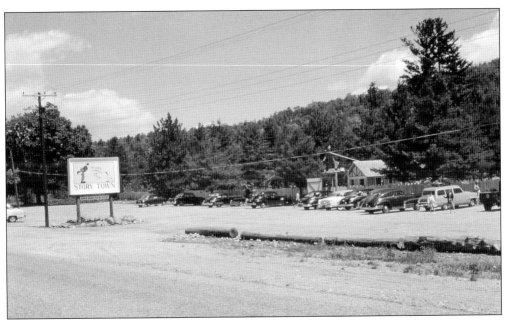

Story Town opened in July 1954. The name was changed to Story Land the following season to avoid confusion with Storytown U.S.A., opened that same summer in Glen Falls, New York. For 85¢ admission, guests strolled through a handful of storybook settings and met characters from fairy tales and nursery rhymes. Opening day generated about $235 in sales, and the 1954 inaugural season drew about 15,300 visitors.

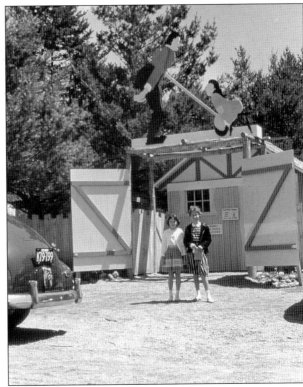

The Story Town entrance gate featured large wooden cutouts of a storyteller and child. The color scheme included a light blue building with a yellow peak and brown and white trim. The pine board fence was unpainted. The signs indicate admission is 85¢ with children under 12 admitted free. Sorry, no dogs allowed.

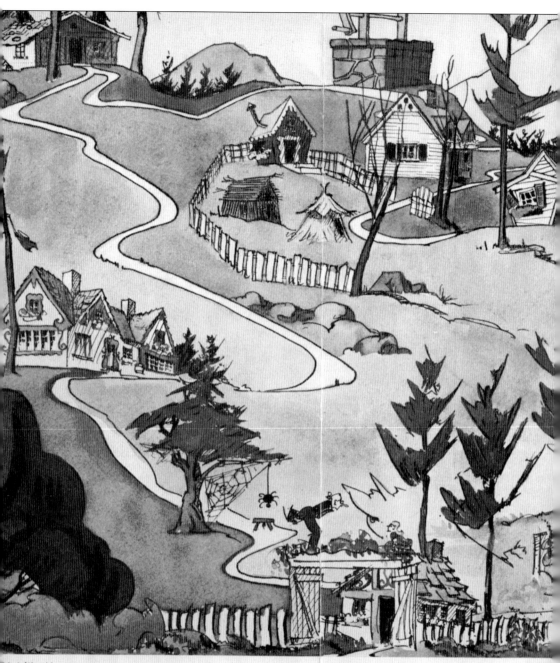

Heidi's House Jack and Jill Pet
 Three Little Pigs
Gift Shop Little Miss Muffet Little Red Hen
 Main Entrance with Story Teller

Storybook World at STORY TOWN • N

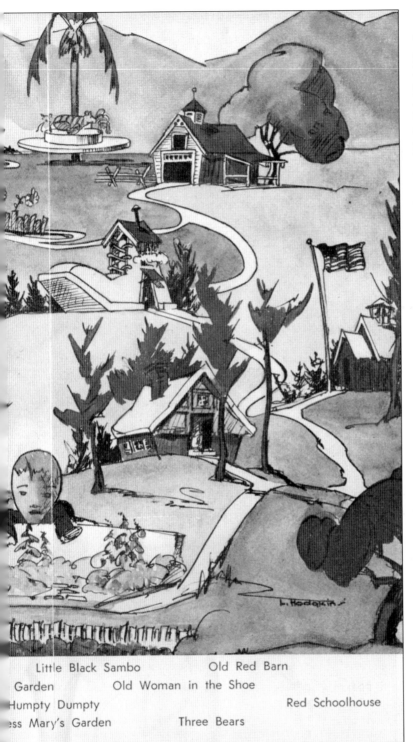

Little Black Sambo Old Red Barn
Garden Old Woman in the Shoe
Humpty Dumpty
ess Mary's Garden Three Bears
Red Schoolhouse

mpshire at GLEN • Route 16

The 1954 park map, drawn by North Conway artist Lewis Hodgkin, illustrates the extent of the features in the beginning. The addition of Freddy the Fire Truck that spring was not included on the map. For years, guests proceeded in one direction around a loop progressing to each feature in order, starting with Humpty Dumpty and finishing with the gift shop, back at the main entrance. Most of these original features have endured, many with upgrades or expansions over the years, and are still found on the grounds today. The main parking lot and entrance, Humpty Dumpty, the Three Bears' House, Schoolhouse, Peter Rabbit, Three Little Pigs, Heidi's House, and main gift shop remain in their original locations, giving today's visitors a feel for the scope of the experience in 1954 Story Town.

13

During the 1954 season, young Nancy Morrell, right, daughter of park founders Bob and Ruth Morrell, spent much of her summer in costume playing characters such as Mistress Mary in her garden. Alongside Nancy is Ruth Duke, who portrayed the Old Woman Who Lived in a Shoe that year. The fence sign was soon replaced by the freestanding fiberglass greeting pictured on page 2.

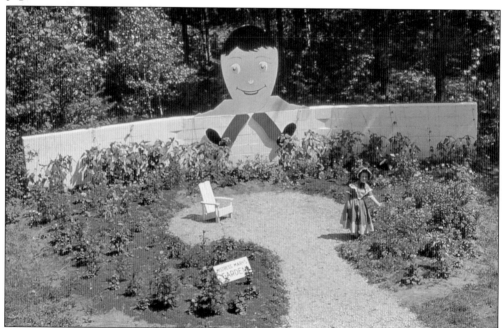

Humpty Dumpty has been greeting park guests since opening day and remains in the same location just inside the front entrance today. He originally appeared as a two-dimensional wooden cutout in 1954. Here Nancy Morrell tends to Mistress Mary's (of the "Mary, Mary, Quite Contrary" nursery rhyme) flower garden.

This unidentified youngster resembling Goldilocks visited the Three Bears' House in 1954. A sign let guests know that the bears were out but had left the door open for children to go inside. This original building, expanded slightly, still stands in the same location and includes a second floor with three beds—one too soft, one too hard, and one just right.

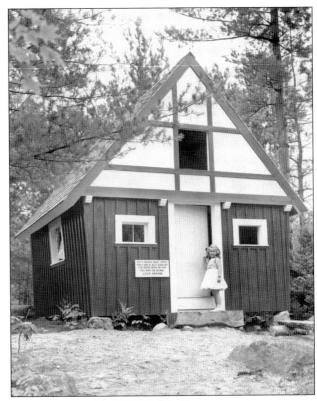

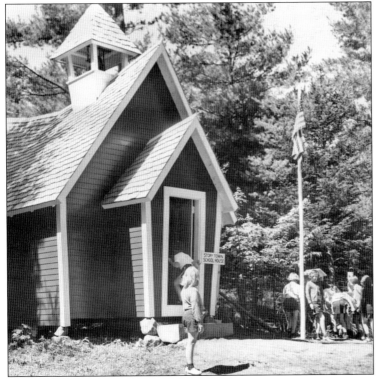

The Schoolhouse today remains essentially unchanged in its original 1954 location. To the right, children feed sheep in an adjacent pen. One important change was made very quickly at children's requests: a rope was added inside to allow everyone to ring the rooftop bell, creating an exercise and distinct sound repeated continuously throughout each day of every Story Land season.

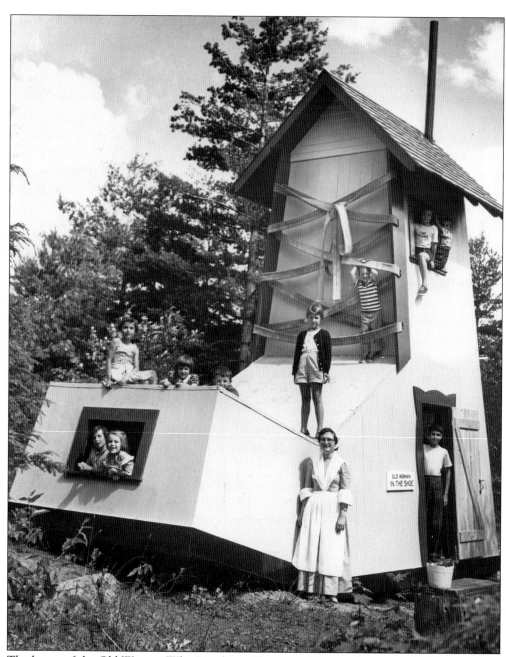

The house of the Old Woman Who Lived in a Shoe was the most distinctive building at Story Land during its first several years. Its popularity with guests helped inspire the architecture for creative features built later. The wood-framed building was covered by canvas, and the shoelaces were made from fire hose stripped from Freddy the Fire Truck. It was built on a site large enough for people to pass through the interior, with small bunk beds added in 1956 that allowed children to participate in the nursery rhyme rather than simply to view it. Along the original 1950s pathway, visitors passed the Schoolhouse before reaching the Old Woman Who Lived in a Shoe, and then proceeded to the nursery rhyme animal pens. This 1954 photograph shows Ruth Duke as the Old Woman in a Shoe, surrounded by so many children she did not know what to do.

In the photograph above, Peter Rabbit occupies the House that Jack Built and plays in Mr. McGregor's Garden. Peter Rabbit was one of several animals at the park representing storybook characters, an approach appreciated by visitors from urban settings where farm animals were uncommon. The original fencing duplicates the larger planks separating the front of the park from the parking lot. The homes for storybook creatures were created on a small scale appropriate to the animals, to help children believe they fit the occupants. The House that Jack Built for Peter Rabbit was actually constructed by Story Land founder Bob Morrell, one of several structures he built himself before the park opened. In the photograph at right, Nancy Morrell inspects her father's work.

Bob and Ruth Morrell's house (left) in the Kearsarge section of North Conway, near Mount Cranmore ski area, was the construction site for several of the storybook animal homes. Neighbors commented to Ruth about the fancy doghouses her husband was building, shown in spring 1954 in the driveway of their Kearsarge Road home.

The homes of straw, sticks, and brick for the Three Little Pigs were made at the Morrell family residence and brought to Story Town in a pickup truck in spring 1954. Each year storybook animals were leased or purchased from area farms, tended to by veterinarians throughout the summer, and returned or sold to farmers at each season's end.

Close-up encounters between children and familiar storybook characters captured the imagination in 1954 and do the same today, with the animals still using original buildings Bob Morrell constructed for the first season. Visible in the left background of this 1954 photograph is the original pathway leading uphill to the wishing well and Heidi's House.

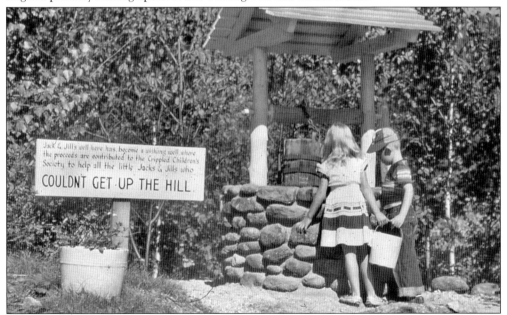

Jack and Jill originally went up the hill above the Three Little Pigs to fetch a pail of water; their well subsequently moved twice. When the Crotched Mountain Foundation of Greenfield, New Hampshire, sought support for its services in 1954, the Morrells pledged to donate proceeds from the wishing well, as this c. 1960 sign notes. The well had generated over $188,000 in contributions to Crotched Mountain by 2007.

The hilltop location of Heidi's House, pictured here in 1968, reminded the Morrells of settings they had seen in Bavaria. They built the house amongst a stand of trees as described in the book and planted Edelweiss flowers in front. The one-way path through Story Land in its early years brought every guest to Heidi's House, which still stands at the peak of the park.

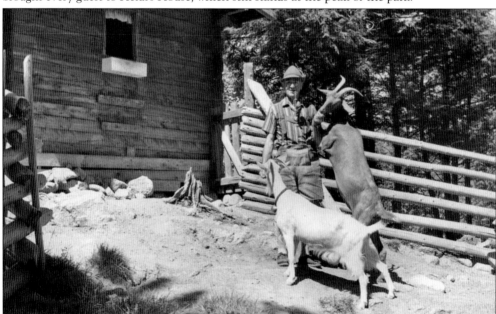

Heidi's grandfather kept pet goats Barli and Schwanli in a backyard pen behind the house. Joseph Carbonneau, shown in 1959, enlivened his grandfather portrayal with some interaction with the animals. Carbonneau was a 25-year management professional with Boston's Filene's Beauty Shop before retiring to a 13-year stint as Heidi's grandfather. He was also bilingual and told the story of Heidi in both English and French to accommodate French-Canadian visitors.

Little Black Sambo's merry-go-round depicted the story of a boy in India who outsmarts menacing tigers by tricking them into running in circles until they melted. Originally located near the animals, it was moved near the gift shop, as photographed c. 1960. The Sambo book was controversial due to its illustrations of the title character. At Story Land today, a simplified tiger merry-go-round is located in the Little Dreamers section.

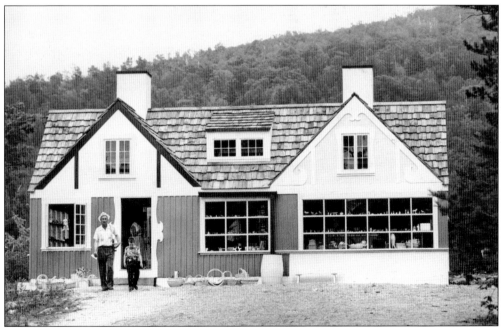

Initially known simply as the "Gift Shop," this souvenir store was renamed Miss Muffet's Market and expanded over the years. It was Ruth Morrell's favorite project at the park, and she oversaw gift shop operations until 1990. Shown in its 1954 original form, the gift shop was the last building to visit at Story Town before heading to the exit.

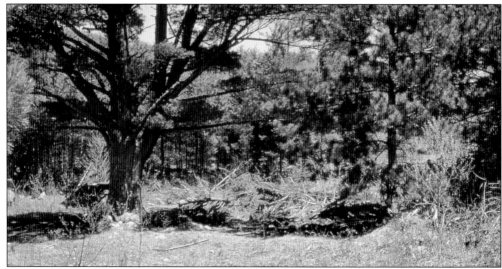

Between the gift shop and the exit stood the large tree seen in the 1953 photograph above. It was transformed into the setting for Little Miss Muffet, below in 1954, with the addition of a simple web and spider. Much like the Humpty Dumpty scene, over the decades this feature proved to be a popular spot for generations of family photographs. Movement was added to the display with a spider that dropped on a cord when children sat on a seat that triggered its descent. The spider scene remained in this spot through the 2001 season when branches were trimmed as a safety precaution. A new Little Miss Muffet was created near the Little Dreamers area, and this tree was transformed once more, this time into an elaborate wooden sculpture.

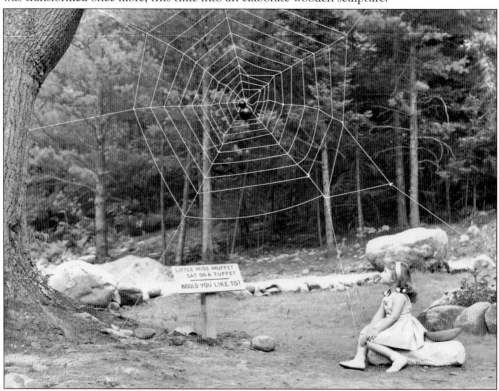

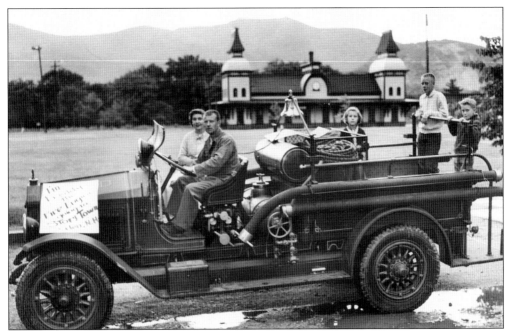

North Conway's Schouler Park provided a scenic backdrop for the above 1954 publicity photograph. The sign reads, "I'm Freddy the Fire Engine going to Story Town, Glen, NH." Posed on the truck are, from left to right, Ruth Morrell, Bob Morrell, Nancy Morrell, Glenn Saunders, and Roger Jones. In the 1954 photograph below, Bob Morrell posed with family members, from left to right, Sally Owen (niece), Nancy Morrell (daughter), and Robert Owen (nephew). Freddy was a fixture at Story Land for nearly 50 years; in 1999 it was sent to Hope, Maine, for complete refurbishment at Firefly Restorations and returned to Story Land in mint working condition by 2001. Freddy made a few public appearances during the park's 50th anniversary celebrations in 2003 and 2004.

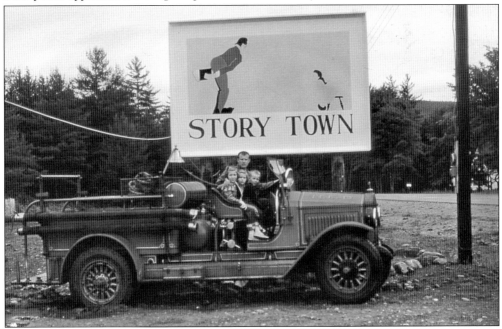

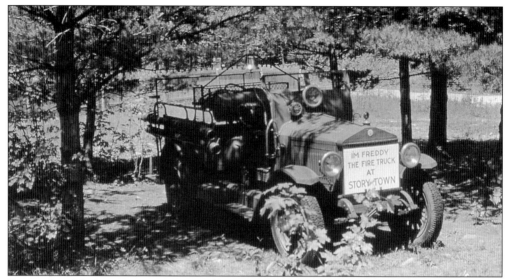

During the 1954 Story Town season, Freddy the Fire Truck was stationary on the front lawn, across from the spider tree of Little Miss Muffet. The vehicle was a 1923 pumper truck manufactured by the Maxim Motor Company of Middleboro, Massachusetts. It was in service with the Hillsboro, New Hampshire, fire department for 30 years and had been designated for scrap auction when it was purchased for the park. Children climbed aboard and imagined heroic missions to be accomplished. The backgrounds in these 1954 photographs, between the parking lot fencing (above) and the gift shop, help indicate Freddy's original location, near where today's visitors see the giant picture frame and Town Hall building.

During White Mountain winters, outdoor attractions yield to snow-oriented activities such as skiing and snowmobiling. Throughout the 1950s, Bob Morrell worked winters at North Conway's Carroll Reed Ski Shops while he and Ruth built their new summer business. During winter 1954–1955, they changed the park's name to Story Land, conceding their original label to a new, similarly named park in New York.

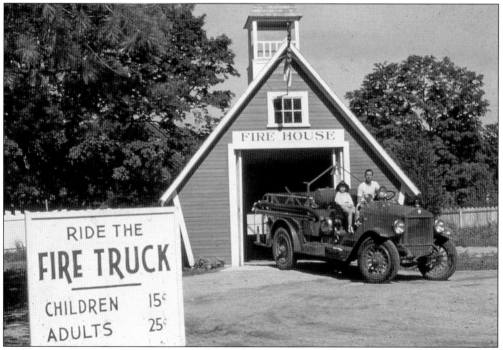

By 1956, Freddy the Fire Truck was the first amusement ride at Story Land. Housed in a new garage near the gift shop, it was driven on a dirt road at the north end of the park, approximately where the Antique Cars ride now operates. Guests paid a fee to ride with a trained driver and could wear real fire helmets and hand crank the siren.

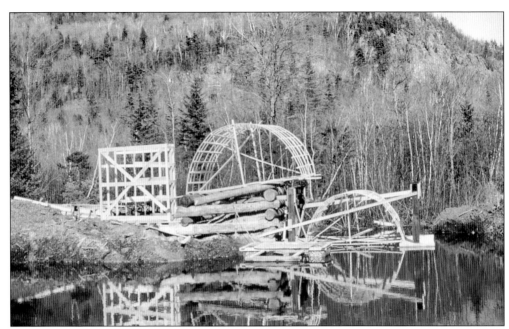

During summer and fall 1956, the Morrells bulldozed land at the southeastern end of the Story Land property, beyond the storybook animal pens. During an August 1956 radio feature recorded at the park for WMOU of Berlin, New Hampshire, reporter Bill Potter said the park looked finished to him and asked what was happening there. Bob Morrell explained that they would like to build a castle on a very nice hill out back with the hope of opening it the next year, if they could do it. These fall 1956 photographs illustrate the pond that was dug by contractor Whit Duprey and the beginnings of bridge construction by Bob and his brother, Nathan Morrell, to connect the path over the pond to the hill beyond.

Two

ROYALTY AND RESILIENCY EVEN IN RECESSION

The 1957 addition of Cinderella's Castle took guests off the original pathway through a gateway into a new realm. Collaborating with local designers and contractors, the Morrells stretched the boundaries and opened a new dimension to the Story Land experience. Young children found the new architecture visually stunning and the horse-drawn coach ride and audience with a princess awe-inspiring.

The expansion generated more encouraging feedback and positive word-of-mouth endorsements from park guests. Visitor suggestions for additional features were considered, and plans were made to research and create the best options. A train ride topped the list with the 1959 season targeted as the debut, even as New England found itself in economic recession in 1958 and revenues at Story Land and other attractions declined by as much as 35 percent.

The unexpected downturn prompted Bob Morrell and other area entrepreneurs to gather to discuss the prospects of working together to collectively promote the region and grow everybody's business. Story Land's promotional folders had since 1954 included other attractions on the locator map to inform guests of complementary activities nearby; pooling resources would strengthen that type of message and lengthen its reach into markets further away.

The discussions led to the founding of the White Mountains Attractions Association in 1958 to cooperatively market the entire region as a resort destination. Similarly focused discussions regarding limited local banking options led to the founding of White Mountain National Bank in 1962 to provide financial resources sensitive to regional tourism businesses. Morrell was elected the first president of both organizations, promotional and financial. He also helped revamp the Mount Washington Valley Chamber of Commerce to promote tourism and quality service standards area-wide, serving as its president in the early 1960s.

Challenges from the recession, met by a cooperative regional response, helped form the outlook and business model that guided Story Land through its first half-century and beyond: creatively liberal and fiscally conservative. The excitement of trying new concepts and introducing new features was balanced by tracking outside economic forces and cooperatively promoting complementary businesses as development and growth continued at the park throughout the 1960s.

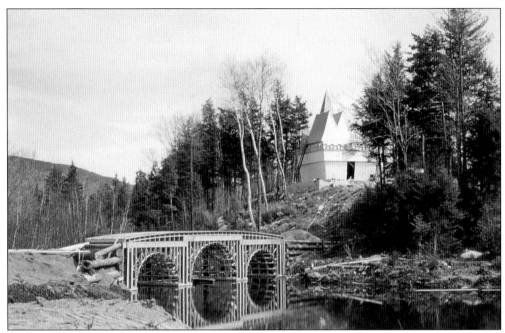

The main features of the new section took shape in fall 1956 before snowfall blanketed the park, keeping the planned expansion on target for summer 1957. The original bridge structure proved to be quite sturdy, lasting through the 2000 season before being replaced with heavy-duty structural steel I-beams and other high-grade modern construction components.

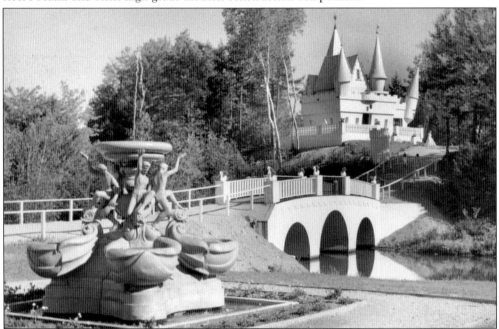

In 1957, Story Land opened its first major expansion with the Cinderella's Castle area. The main attraction was a tour of the castle hosted by the princess herself. Guests could walk over the bridge or ride in a horse-drawn pumpkin carriage. Other new structures framing the area included a turreted wall with a drawbridge gate and a working stable for horses.

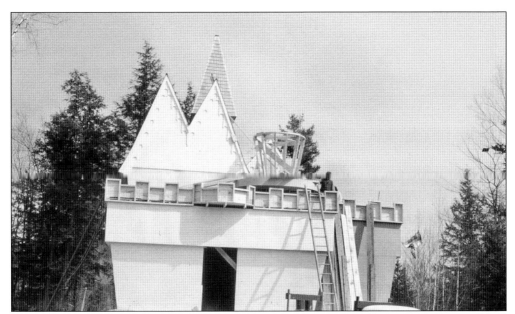

Work on the new castle area had progressed smoothly through the fall of 1956. Bob Morrell had told a WMOU (Berlin, New Hampshire) radio reporter in August that building crooked walls was much more difficult and expensive than erecting straight ones, but that the result was worth the investment for the structures at Story Land. Bartlett, New Hampshire, carpenter Wayland Cook and his crew met the construction challenges presented by the designs of Topsy Samuelson from Intervale, New Hampshire, struggling a bit with the creation of the crooked towers on the castle front. George Young's metal shop of Fryeburg, Maine, was responsible for the metal spires for the castle and the drawbridge gate. The result became the signature building as well as the featured scene in Story Land promotional materials for the next five decades.

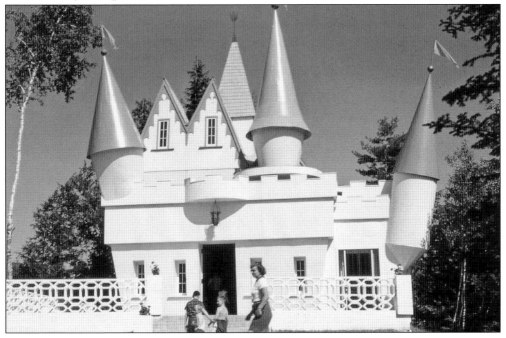

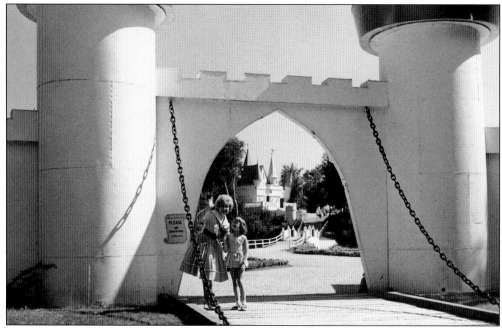

A wall with a drawbridge accented transition from the pens of storybook animals to the splendor of Cinderella's Castle area. Photographed in 1961, the gateway frames the castle on the hill and creates the sense of entering a new realm. Reflecting a regal policy ahead of its time, the sign reads, "Please, no smoking in the area."

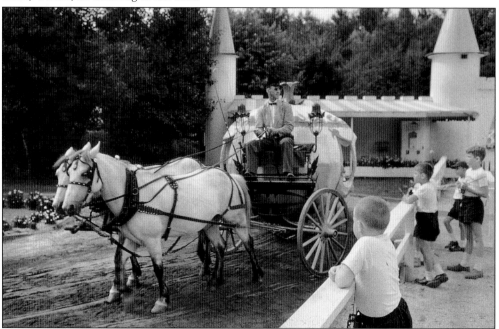

To the right, after passing through the castle gate, was the new Pumpkin Coach ride, photographed in 1961. A team of live horses drew the carriage on a gravel path uphill to Cinderella's Castle. A return ride was offered as well, although walking across the bridge was an option in both directions. Live horses were part of the Pumpkin Coach ride through the 1979 season.

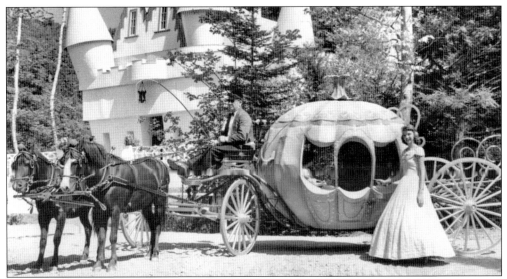

In 1957 and for many years thereafter, Cinderella met each Pumpkin Coach arrival and escorted her guests inside for the tour. The practice often resulted in actors portraying the princess by day and working like the pre-princess Cinderella by night, cleaning their own dresses at home of dirt and horse-generated pollutants. Unlike today's policy of unlimited rides included in the price of admission, from the 1950s through 1978 guests paid separately for admission to the park and for rides, at various times exchanging cash, tickets, or a tally card (settled with cashiers at the exit) with ride operators. In these 1957 photographs, Jackie Hayward portrayed Cinderella, and Alfred Morton drove the Pumpkin Coach, which was built locally from designs drawn by Bob Morrell.

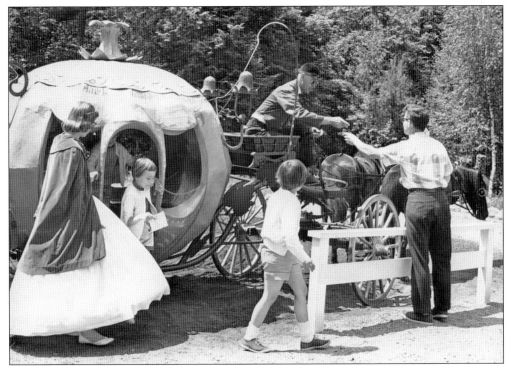

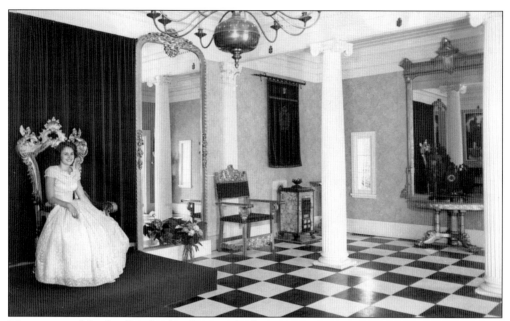

The interior of Cinderella's Castle, photographed in 1961, is an imposing but friendly environment for young fans of the princess. Its impressive appearance was created through some frugal acquisitions of secondhand furnishings such as a gilded throne and chandelier from a New York estate, large mirrors from a Baltimore mansion, and marble wainscoting and ironworks from a Concord, New Hampshire, bank.

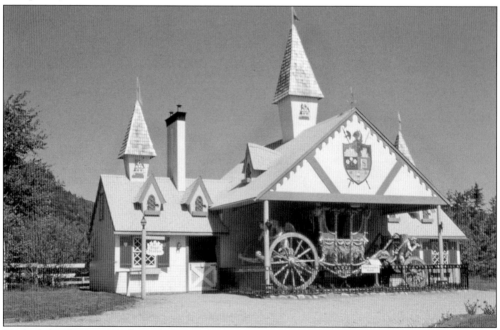

To the left, after passing through the castle gate, was the new Ye Royal Stables, shown here in 1957. The back side was a working stables area for the horses that pulled Cinderella's Pumpkin Coach through 1979. The front side featured a replica coronation coach for British royalty. Today's visitors to Story Land will recognize the stables as the main portion of the Let's Pretend gift shop.

Through 1979, the business end of Ye Royal Stables held stalls, pictured in 1961, for the horses that delivered guests to Cinderella's Castle. In 1980, the original Pumpkin Coach was replaced by a motorized vehicle with a gasoline-powered engine, and the stables were renovated into the home of the Epsom Downs horse race game. In 2000, the Let's Pretend gift shop opened here.

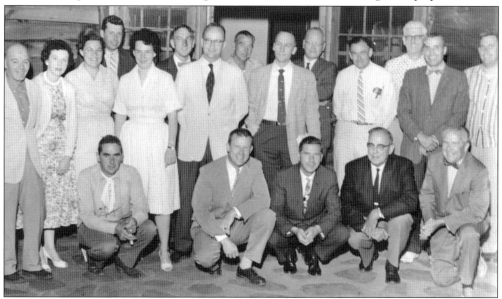

From his first 1954 park brochure, including a map publicizing 10 other attractions, Bob Morrell saw great value in cooperative regional promotion. The White Mountains Attractions Association, originally the White Mountains Recreation Association, organized in 1958, according to its 1960s membership pamphlet, to increase tourist flow, cooperatively promote and publicize the region, and assist in promoting New Hampshire for vacation travel. This 1960 association photograph shows Morrell, its first president, in the first row, second from left.

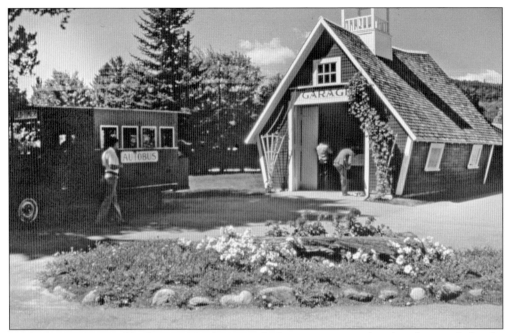

By the late 1950s, Freddy the Fire Truck was parked in its garage and replaced as a ride by the Old Time Bus, a basic vehicle easier to maintain and simpler to operate. It travelled the same gravel road that Freddy had driven. The bus itself, shown at left in a mid-1960s photograph, was permanently parked in 1961 when the Antique Cars ride was introduced.

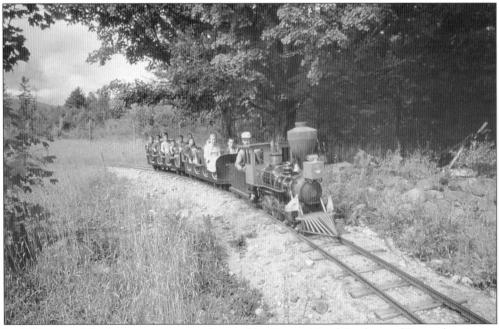

In 1959, a wood-fired steam train manufactured by Crown Metal Products of Pennsylvania was introduced as Story Land's third ride—the Huff Puff and Whistle Railroad—to complement Cinderella's Pumpkin Coach and Freddy the Fire Truck's replacement, the Old Time Bus. The miniature passenger cars were ideal for children and capable of accommodating adults as well.

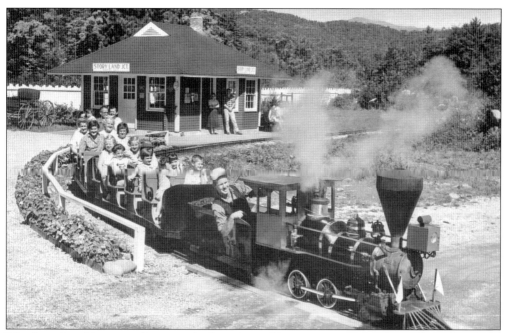

The Story Land Junction depot was built in the park's northwest corner. It was the only stop for passengers of the Huff Puff and Whistle Railroad, which stretched into undeveloped wooded sections of the property to the east beyond the gift shop. Through the 1960s, candy and gum were sold at Story Land Junction, photographed in 1959.

Passengers on this 1960 train ride crossed the road for the Old Time Bus and passed firewood and a water tower (today at the raft ride) for the steam train. The roof of the gift shop is visible above the railroad crossing sign. It was full steam ahead for Story Land. This scene changed in 1961 when a train tunnel and entrance to a new ride was built here.

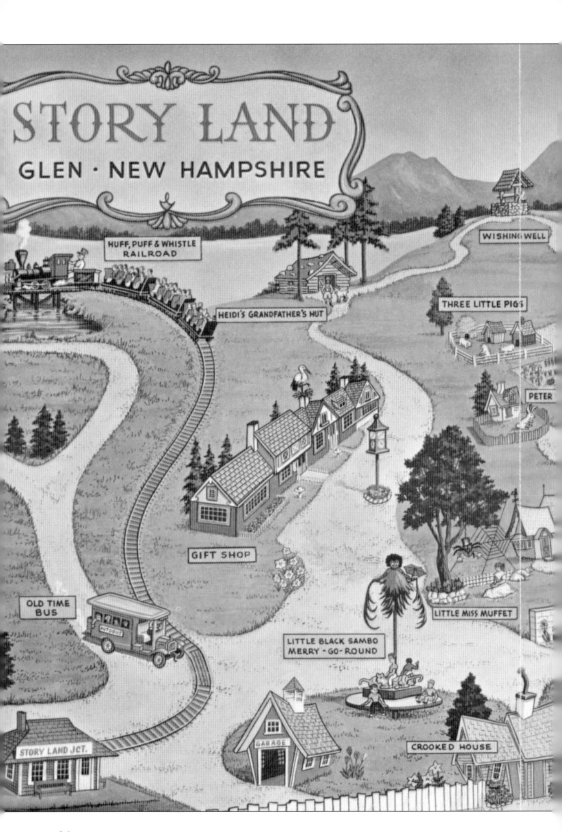

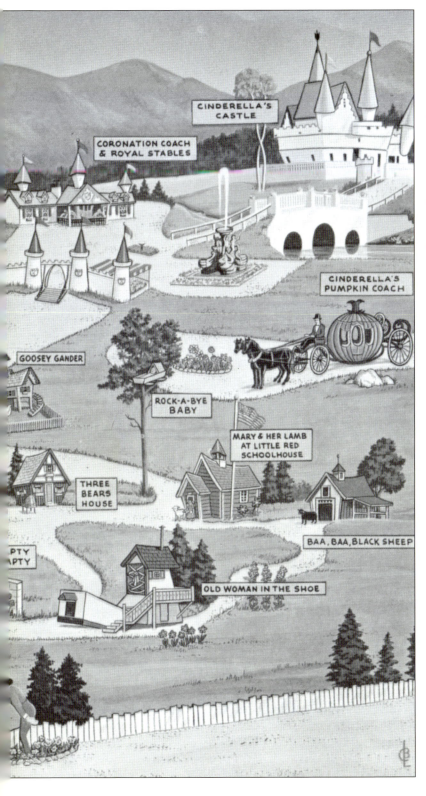

The 1960 Story Land park map illustrates the expansion of the park since opening in 1954 (pages 12 and 13). To the southeast (upper right) is the Cinderella's Castle area; to the northwest (left) are the Old Time Bus ride and the Huff Puff and Whistle Railroad. Freddy the Fire Truck was housed in the garage at lower left, and the park entrance had been enlarged with a new Crooked House building. The original building was moved inside as the structure for the Pixie Corner refreshment stand. With the exception of the bus, all of the features appearing on the map in 1960 can still be found at Story Land today, most in the same locations and several in their original forms.

37

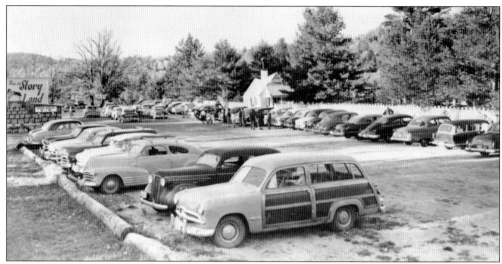

The Story Land parking lot around 1960 was not yet paved and accommodated fewer than 100 cars at a time. Humpty Dumpty had replaced the storyteller as the main figure on the front sign. This view to the northeast from NH Route 16 includes the Crooked House entrance building and a glimpse of the gift shop roof amongst the trees on the right.

The Crooked House entrance building has been the unique front gate to Story Land for over 50 years. The building pictured in 1961 remains as part of the current enlarged Crooked House entrance today. In a 1956 WMOU (Berlin, New Hampshire) radio feature recorded at Story Land, Bob Morrell told the host the park received some kidding about the entrance with inferences that the cashier might be a crooked man.

The Pixie Corner in the 1950s became the first refreshment stand at Story Land. Guests originally were encouraged to bring lunches to enjoy at picnic tables, with soft drinks and ice cream sold at the gift shop; even after the addition of park food service, guests still were permitted to bring their own. The original entrance building (page 11) is the structure for the Pixie Corner, photographed around 1960.

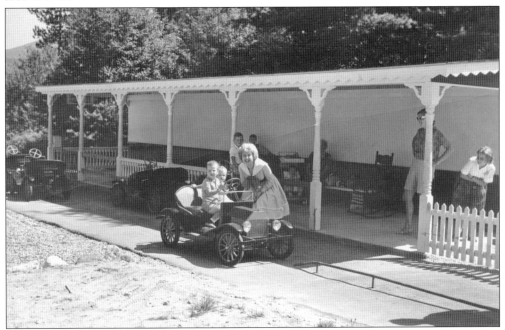

In 1961, Story Land introduced the Miniature Model Ts Antique Cars ride at the north end of the park. The Old Time Bus was permanently parked near Freddy the Fire Truck, and a 1,000-foot winding asphalt track was paved where the bus and fire engine had previously travelled. A shaded entrance for the ride was built behind the gift shop, just north of the railroad tracks.

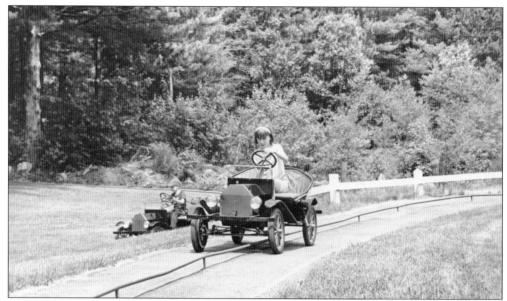

The original fleet of miniature Antique Cars at Story Land operated from 1961 through 1970 before being replaced by a second generation of cars also built in-house. The 1960s cars featured gasoline-powered engines and a single bench seat to accommodate up to two riders at a time. A guide rail in the center of the pavement helped keep cars on track, although leeway for steering the width of the wheelbase required some focus and skill to ensure a smooth ride. A covered bridge allowed for a loop and underpass to add length and character to the track.

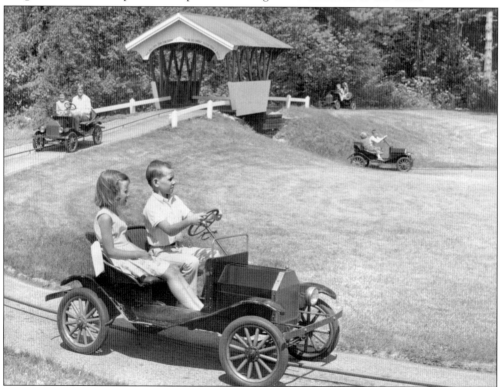

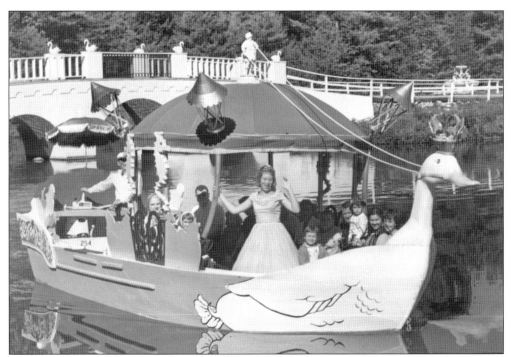

Story Land's first water ride was the Story Land Queen passenger boat, introduced in 1963 (above). From a mooring in the waters below Cinderella's Castle, just northeast of the footbridge, a captain piloted passengers in the motorized, free-floating boat without underwater tracks or guide rails. Intervale, New Hampshire, woodworker Rodney Woodard handcrafted the large, crowned duck head that adorned the bow. In 1968, a working drawbridge was added along the channel as a special effect to visually enhance the voyage. The original Story Land Queen duck boat sailed for over two decades before being replaced by a larger swan-fronted passenger ship in 1987.

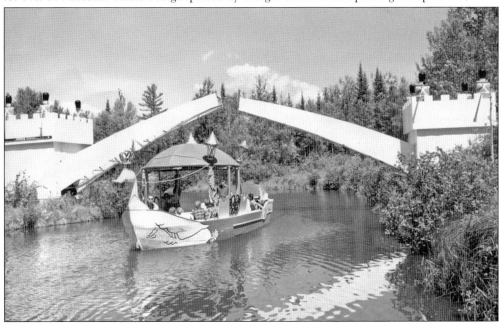

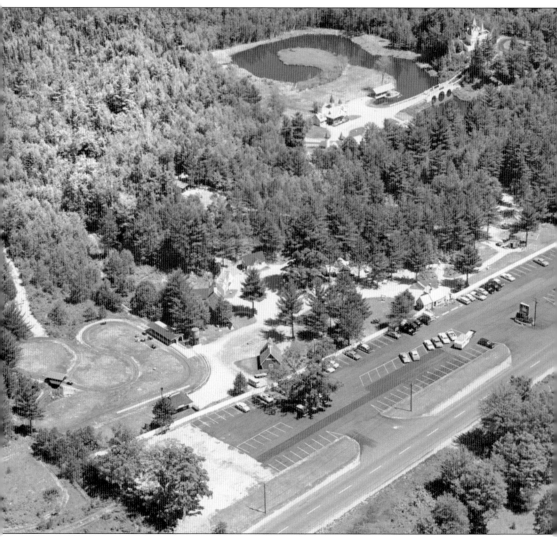

An aerial photograph taken during Story Land's 10th anniversary season in 1964 reveals both the park's core development and opportunity for the growth that came later. Visible in the upper right is Cinderella's Castle, footbridge, and stables, as well as the Story Land Queen boat and dock. At lower left is the Antique Cars track, along with the Story Land Junction depot. Heidi's hilltop house is visible just left of center, between the pond and the car track. On the front lawn inside the park, just left of the Crooked House entrance, is the giant step-in picture frame where countless families have posed for portraits for over half a century; the frame was moved in 2008 to a spot on the lawn closer to the gift shop. The parking lot, just a fraction of today's size, was initially paved in 1962. The front sign along NH Route 16 in this photograph features Cinderella's Castle on it and has two tiny cedar trees on its sides; today each of those trees has grown to be larger than the sign.

In the early 1960s, the original Humpty Dumpty was replaced with the current three-dimensional metal-and-fiberglass version. Mistress Mary's garden, and others, grew significantly under the care of Bob Morrell's father, Nathan, and longtime gardener Donald Martin. Bob explained in a 1973 local newspaper interview that investing in gardens showed respect for the environment and that children respond with similar respect, and environmental care would help draw future vacationers to the area.

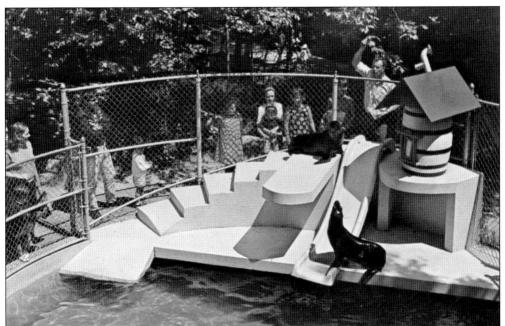

From 1965 through 1972, Story Land was home to Mr. and Mrs. Seal. The park's only sea animals swam in a pool near the front of the park, approximately where Peter Pumpkin Eater's House currently stands. They were replaced with trout for a few years in the mid-1970s, before the pool was converted into Story Land's first ball crawl in 1980.

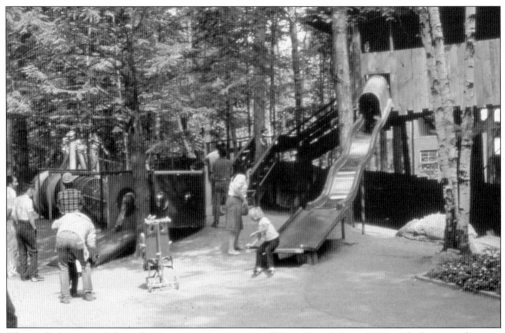

Themed playgrounds have been an important part of Story Land since 1966 with the introduction of the Tree House play area. The original Tree House, photographed in 1970, was located near the seal pool, just up the path from the Three Bears' House. The site eventually became the location of restrooms.

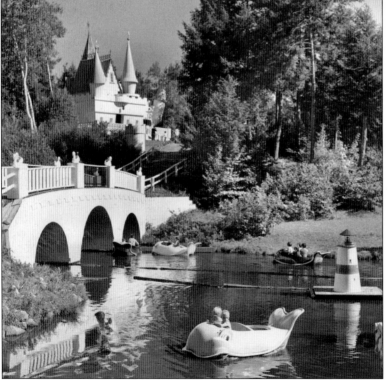

Miniature Whale Boats cruised the waters below Cinderella's Castle from 1967 until 1970, when they were replaced by Swan Boats. Their electric motors were plugged in nightly for charging, and a steering mechanism allowed guests to pilot their own boats. The small fleet of red, yellow, and blue whales was stationed near Cinderella's footbridge, opposite the Story Land Queen boat.

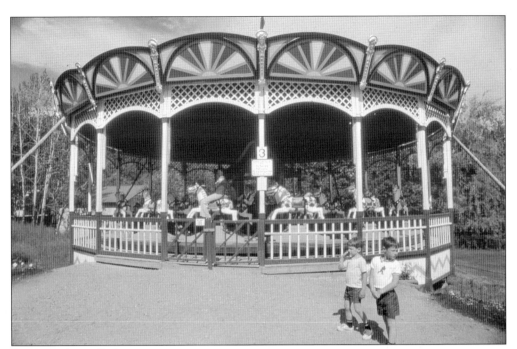

Story Land installed an antique Heyn German carousel in 1967. It was originally steam powered and toured the Bavarian countryside in carnivals during the late 1800s and early 1900s. A Canadian carousel collector purchased it, and it appeared at Toronto's Canadian National Exhibition grounds in the early 1960s. Story Land bought it in Canada and installed it with an electric motor in its permanent location at the park. The above 1974 photograph illustrates its unusual clockwise rotation, opposite of the more common counterclockwise carousel motion. The 1985 photograph at right shows the spring-loaded wooden bases for riders to rock their own hand-carved wooden horses, rather than the common motor-driven pole through carousel horses. Story Land equipped the ride for wheelchair accessibility in 2005, using a ramp and adding bench seats that open to accommodate and secure a chair.

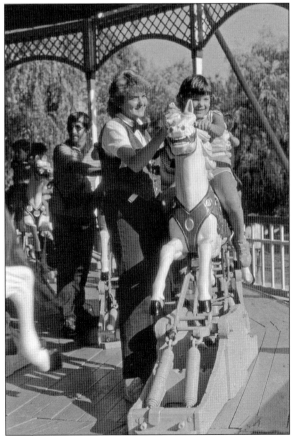

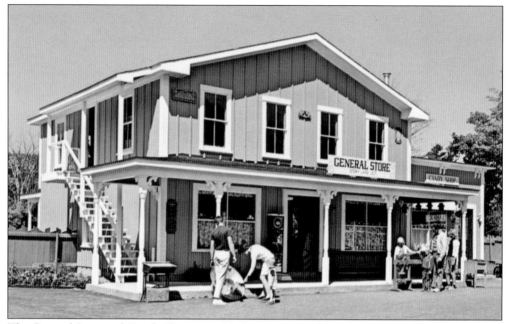

The General Store and Candy Shop was added in 1967 near the Story Land Junction depot in the front of the park. The theme was a late-1800s village building set near the train, Antique Cars, and Freddy the Fire Truck. The upstairs storage area was later transformed into the main office for the park, and the building has seen several two-story extensions over the years.

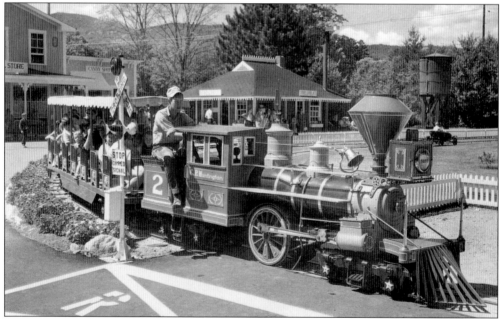

C. P. Huntington engine No. 2 made by Chance Rides Manufacturing of Wichita, Kansas, replaced the original Story Land steam train in 1967. It is a gasoline-powered locomotive that is simpler to maintain and operate than the steam engine. It also had larger passenger cars. Story Land eventually purchased five of these locomotives and today operates up to three at a time on one looping track.

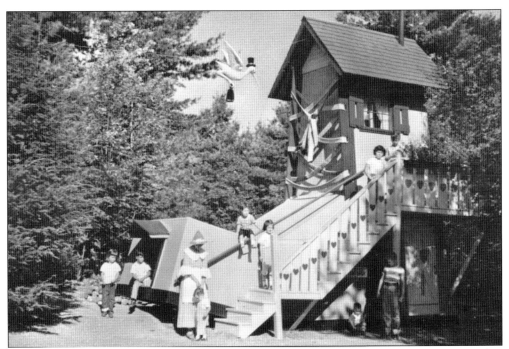

The original home of the Old Woman Who Lived in a Shoe (page 16) was a canvas-covered wood frame that was enhanced, as shown in the above 1958 photograph, with a staircase to the second floor and a stork constantly poised to deliver another child. The new shoe house in the 1970s photograph below was introduced in 1968 and continues in use today. It consists of a stucco-encased wooden frame and was created on-site at Story Land. For decades, the Old Woman Who Lived in a Shoe has greeted young visitors with a Story Land sticker (which replaced a pin) that most wear on their shirts throughout their visits and into the evening.

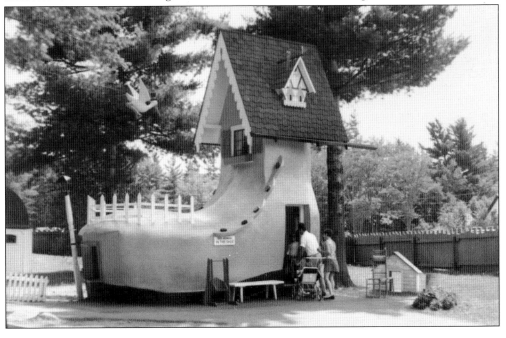

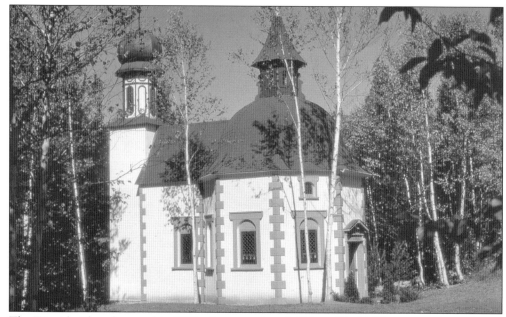

The Wayside Chapel opened in 1969 a few steps downhill from Heidi's House as a place of quiet nondenominational respite, modeled after a larger chapel in Seefield, Austria. It is octagonal in shape and has two onion domes topped with copper balls from 1950s research laboratories atop Mount Washington. Building plans were created by studying postcards of the original chapel. Its 40-foot height exceeds its width, inspiring most who enter to look skyward.

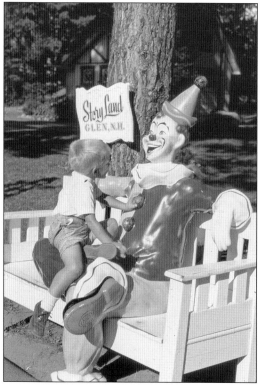

The fiberglass clown in this 1970 photograph has been a permanent fixture at Story Land, near the Pixie food stand, since 1969. A cornerstone of the park's business philosophy was to frequently add simple props that appealed to children and helped create a lasting memory, even if it did not generate a measurable return on investment by itself.

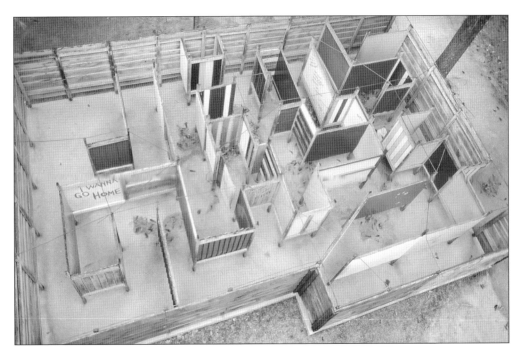

Even as Story Land built on steady growth during the 1960s with an ambitious development program for the early 1970s, park management held to a belief that there is genius in simplicity. The 1984 photograph below provides an overhead view of a maze created in 1971. The open walls at floor level allowed parents outside to keep track of children inside the basic wooden structure. The 1982 photograph at right illustrates the location of the maze (the wooden structure on the right) near the Old Woman Who Lived in a Shoe. It lasted for two decades, with some late-1980s renovations, until the Grandfather Tree play structure was placed there in 1995. The Sambo merry-go-round was reduced from its original size (page 21) when relocated here; visitors today will find the merry-go-round in the park's Little Dreamers section.

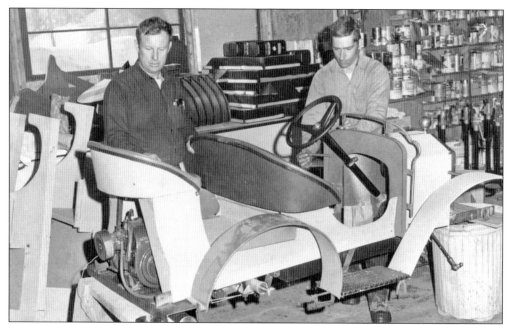

In the winter photograph above inside the Story Land maintenance building, Bob Morrell (left) and John Moulton worked on the second generation of miniature Antique Cars. Unhappy with the cost and quality of vehicles from outside manufacturers, Morrell had decided to build in-house. A second seat was added to the new cars to increase ride capacity and allow parents to take a back seat while children drove. The photograph below shows the cars during the 1975 season. These gasoline-powered vehicles operated through the 1999 season, each logging an estimated total of approximately 75,000 miles before being replaced by electric-motored vehicles in 2000.

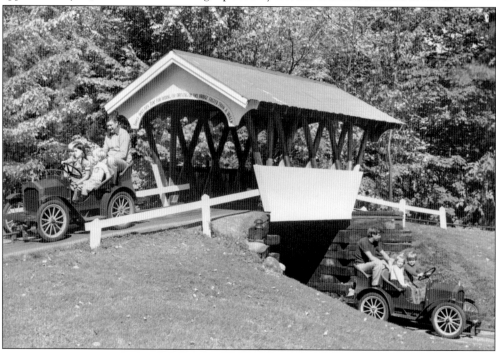

Three

SAFE, SMOOTH, SMILING, SPOTLESS SERVICE

Taking a lesson from mentor Carroll Reed, founders Bob and Ruth Morrell instilled a simple philosophy at Story Land: if you take care of people, numbers take care of themselves. The only number emphasized outside of the business office was five, with every encounter governed by the park's Five Ss: safe, smooth, smiling, spotless service.

People were hired based on attitude over skills, and attributes such as politeness, punctuality, good grooming, courtesy, cleanliness, and enthusiasm were reinforced and rewarded. Employees had become known as "cast members" to emphasize that every moment is a show for each guest. The message behind the term was that everyone performs an important role in the production, whether emptying a trash can, operating a carousel, or portraying a princess showing wide-eyed children a glass slipper in a castle.

Story Land developed a culture of warm personal interaction at all levels, from management to staff to guests, and with others in the community as well. Repeating thousands of high-quality one-on-one encounters every day, from the morning's first visitor through the evening's last, set Story Land cast members apart from other service workers. Visitors still regularly write to the park to say how much they recognized and appreciated one, or several, of the Five Ss during a visit.

Listening and responding to guest and staff feedback regarding one feature or another helped direct development in ways certain to please park visitors. Every comment was given consideration, many were studied to see if they could be accomplished, and countless suggestions were acquired, built, or created. Profits were reinvested into the development of the park consistently and carefully to avoid taking on outside debt. Story Land guests and staff shared the collaborative spirit of the park's management and returned each summer to enjoy the enhancements.

To start the 1970s, Story Land embarked on a five-year development plan, representing its first major expansion since the addition of Cinderella's Castle in 1957. Called A Child's Visit to Other Lands, it reflected the Morrells' enjoyment of travelling and their appreciation of other cultures and was presented in a fun environment for children.

By 1968, the Crooked House entrance building had taken on the appearance it has held into the new century. The two-story addition on the right side not only provided space for more cashiers and greater flexibility on the ground floor, it also created a main office on the second floor.

The giant step-in picture frame at Story Land has been on the front lawn for over 50 years and has hosted generations of family portraits, including this 1995 photograph of three generations of the Morrell family. From left to right are Stoney; his daughter, Halie; his son, Taber; and his father, Bob.

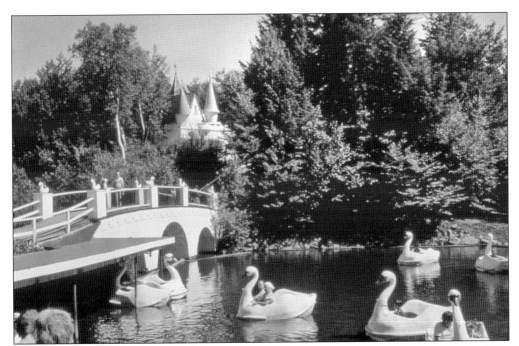

The miniature Whale Boats below Cinderella's Castle were converted to Swan Boats in 1970, more in keeping with the scenery and theme of the entire castle area. The silent electric motors and mild speed of the Swan Boats set a calm tone for the relaxing ride in a majestic setting.

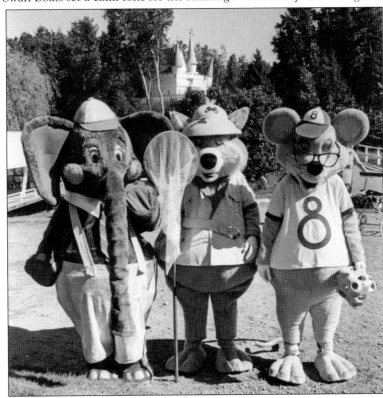

Story Land introduced its own cast of roaming characters in 1972. Designed by the park's longtime in-house artist, Donna Howland, the costumes were custom made in California. The primary character was Ollie, the green elephant, and his friends included a lion that chased butterflies and a mouse that loved cheese, photographed in the castle area in 1974.

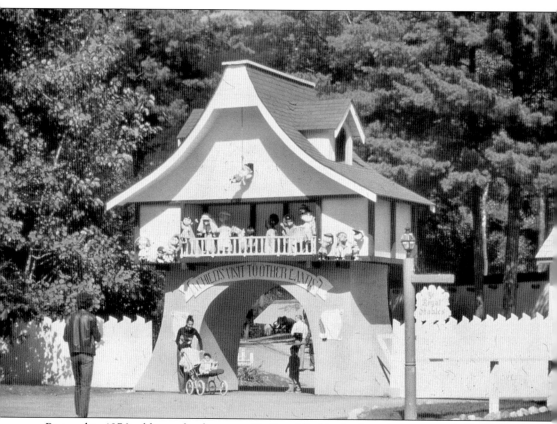

Pictured in 1976, a blue arch adjacent to Ye Royal Stables beckoned visitors to A Child's Visit to Other Lands, a five-year project introduced in 1971. It involved construction of a food stand, gift shop, theater, and walk-through attraction, plus installation of amusement rides and the addition of more animals. Other lands to be represented included Morocco, Africa, the Netherlands, Mexico, Switzerland, and the Arctic. It was the first expansion of park boundaries since Cinderella's Castle area, and it encompassed more land and features than the 1957 project. In *New Hampshire Profiles* magazine (August 1975), Bob Morrell explained why the development retained the park's focus on families with young children rather than reaching for a broader market: "We are trying very carefully to maintain one theme rather than become just another amusement park, as so many have. We also try to make the best use of our natural setting." That focus was maintained into the 21st century.

The Moroccan Bazaar, photographed in 1972, was an early feature within A Child's Visit to Other Lands. The two-story cinder-block-and-wood structure was built into the eastern slope below Heidi's hill. Its uses varied over time; originally a lower-level gift shop and upper-level sandwich shop, it housed a theater and ice cream shop in its final seasons. In 2005, it was razed and replaced by the Flying Carpet sandwich shop.

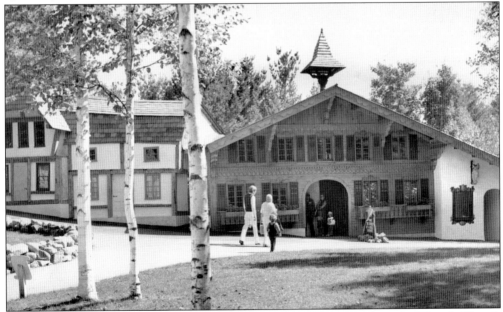

In 1974, the air-conditioned Swiss Theatre opened on the hilltop across from the Wayside Chapel, near Heidi's House. It featured *Let's Pretend*, an eight-minute, three-screen slide show with recorded sound and storytelling, and played every quarter-hour. It was written and produced by Alexandria, New Hampshire, playwright Peter Stone. The revised show advertised in this late-1970s photograph was called *The World of a Child*.

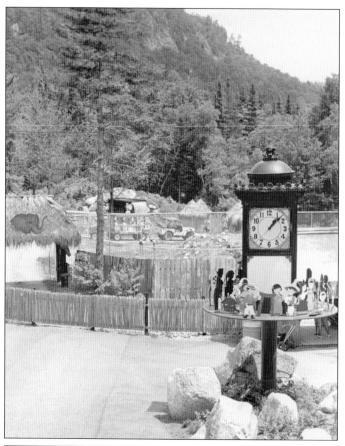

Across from the Moroccan Bazaar was the African Safari ride. The mid-1970s photograph at left illustrates the large area covered by the original safari setup. The rooftop directly to the right of the clock covered the loading area for riders. In between the wooden fences in front was the track for the Huff Puff and Whistle Railroad. In back, behind the fencing and the ride vehicle, were the waterfall and other features guests today might recognize within the current Slipshod Safari ride. Live animals roamed the land inside the chain link fence in the center; the 1978 photograph below shows the gazelle-like animals. The land where they grazed is now the site of the Friends Around the World Food Fair and World Pavilion.

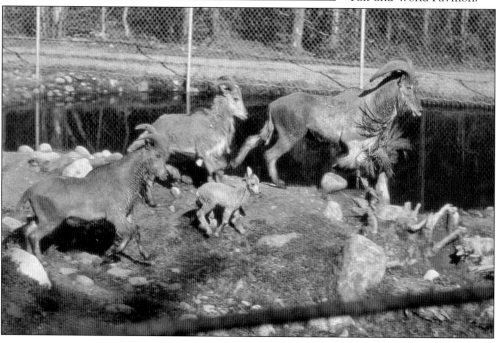

Guests in 1975 loaded the African Safari wagon train from the shelter on the right. Story Land guests standing in that same location today would be loading on to the Huff Puff and Whistle Railroad train from the Whistle Stop Station shelter (note the train tracks to the left of the safari vehicle).

During the mid-1980s, the live animals were removed and the land area for the safari ride was reduced. The loading station was converted into the Lubumbashi train stop, seen here in 1985, to load and unload rail passengers. The Circle of Friends Theater was built where the animals used to roam and opened in 1987.

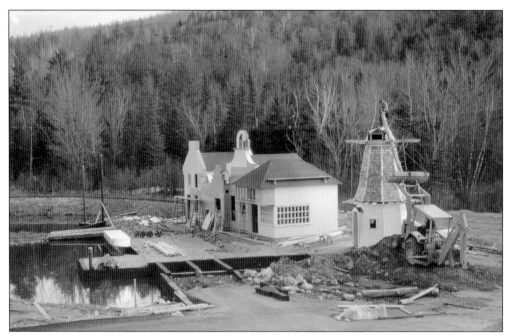

The Morrells had become friends with Arto Monaco, who opened his Land of Make Believe in 1954 in New York's Adirondacks region, and shared a similar wavelength regarding family parks. Monaco provided ideas and sketches for A Child's Visit to Other Lands, most notably inspiring design elements of the Dutch Village, opened in 1972. The above 1971–1972 construction photograph illustrates transition from raw land to foreign land. A 1973 postcard photograph shows the new village with windmill, gift shop, and the Flying Dutch Shoes ride on its own island. The Allan Herschell Company of North Tonawanda, New York built the customized ride. Behind the free-floating cruise ship, to the right of the gift shop, a fieldstone dike leaked water through a single hole; an adjacent sign told the story of the Dutch boy plugging it with his finger.

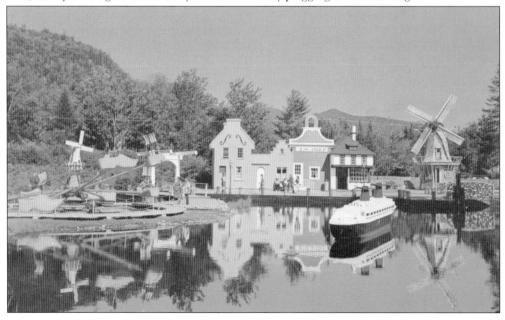

This 1973 photograph shows the cobblestone path from the bridge of the Flying Dutch Shoes ride toward the Moroccan Bazaar in the distance. The vegetated area on the right was developed as part of the roller coaster ride in 1975. Over the years, the cobblestone was reduced and eventually removed altogether in favor of blacktop to improve pedestrian and stroller safety.

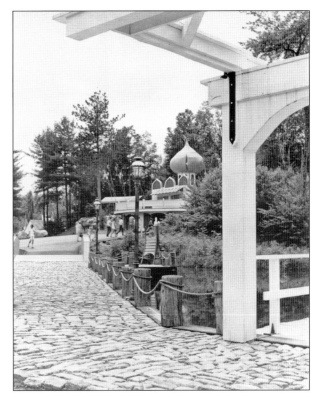

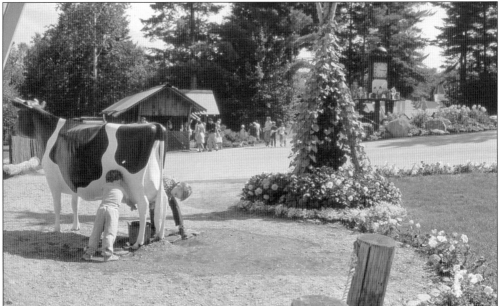

In 1982, children used imagination with the milking cow in the Dutch Village, directly in front of the windmill. The entrance to the safari ride is in the background. Tap water supplied to the cow's rubber udder through a buried line fed into the body allowed children to "milk" the cow, while a recording played a consistent mooing sound. The cow remains a popular diversion at Story Land today.

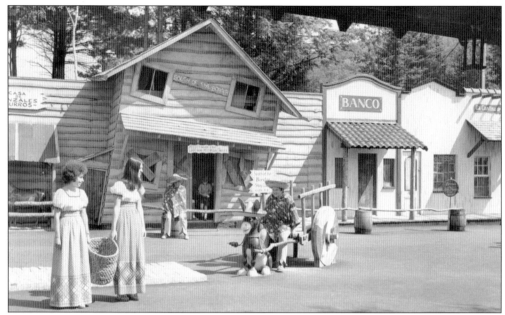

South of the Border opened in 1973 through the archway from the castle area. It included Story Land's original, dark walk-through experience, the Silver Mine walk-through tour. It featured illusions and special effects such as a bottle rolling uphill on an uneven table, a spring-mounted "elevator" with mine-shaft wallpaper scrolling upward in a window as guests "descended," an echo chamber, collapsing rafters, and the spinning "special spiffy silver sifter."

In addition to the Silver Mine (left, behind the archway in this 1999 photograph), South of the Border eventually included the Villa San Jose gift shop and adjacent Shooting Gallery game, a food stand with a Mexican-style menu, and the Los Bravos Jail. The Epsom Downs horse race game (which moved to the Villa San Jose site in 2000) was in the stables building.

Climbing the hillside between the Moroccan Bazaar and the Dutch Village in 1975, the Ice Berg Coaster was publicized as Story Land's largest and most expensive single project in its history, costing $100,000. The ride was engineered to take advantage of its hillside setting. The vehicles, designed to resemble blocks of ice gliding over the tracks, were made by Bradley and Kaye of California.

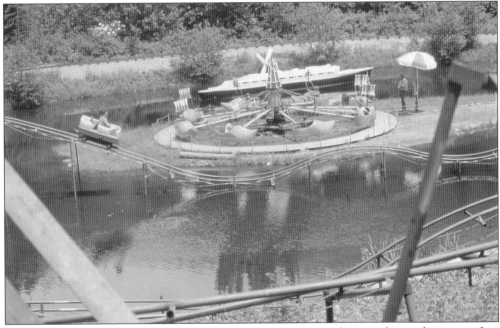

The Ice Berg Coaster cars rode on tubular steel tracks mounted on similar steel supports. Just before entering the station, the ride finished with a series of dips just above pond level next to the Flying Dutch Shoes ride, as shown in 1975. The tracks for the Huff Puff and Whistle Railroad are visible in the background.

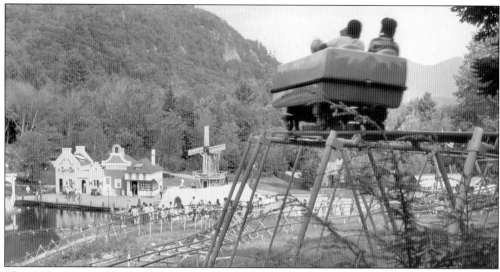

The 1975 opening of the Ice Berg Coaster marked the culmination of the five-year development of A Child's Visit to Other Lands. The results were three major new rides, a dark-ride walk through, an air-conditioned theater show, additional gift shops and food stands, a seasonal staff of over 100 employees, and over 150,000 annual visitors. Other enhancements continued in the next few years because, as Bob Morrell told *NH Profiles* magazine (August 1975), "You can't sit and ride on your momentum in this business." Through 1978, guests rode by purchasing individual ride tickets or packages, such as the Big Deal for children or the Adult Adventure for parents, in addition to paying a separate admission fee.

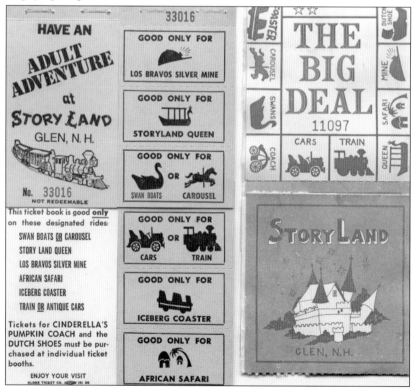

A log fort playground opened in 1977 on the hilltop near Heidi's House. Simply labeled The Fort on park maps, it was larger and contained more elements—like the log buildings, net climb, and slides in these mid-1980s photographs—than the Tree House of the time at the front of the park. The Fort was located adjacent to the top of the Ice Berg Coaster and held its position there for about 20 years. In the late 1990s, the Soggy Froggy squirting frogs were moved here for a few years; visitors to Story Land today will find the Cuckoo Clockenspiel ride in this spot.

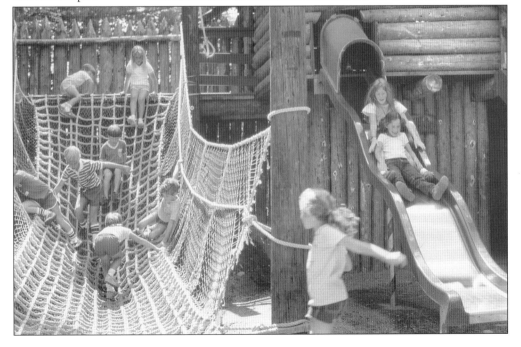

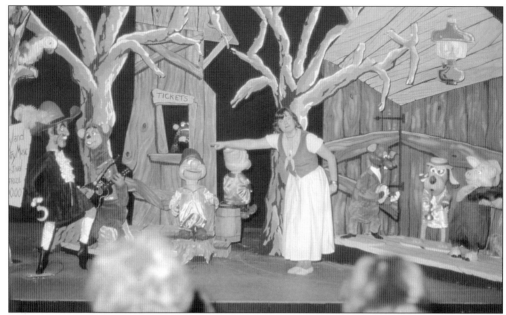

Story Land's first animated puppet show made its debut in the hilltop Swiss Theatre during the park's 25th season in 1978. The Ted E. Bear Jamboree was written and produced by Peter Stone, a frequent creative collaborator responsible for the park's original theater show and the Heritage-NH attraction. The Jamboree featured a live actor as Miss Snowflake, animated puppets, and a recorded musical soundtrack.

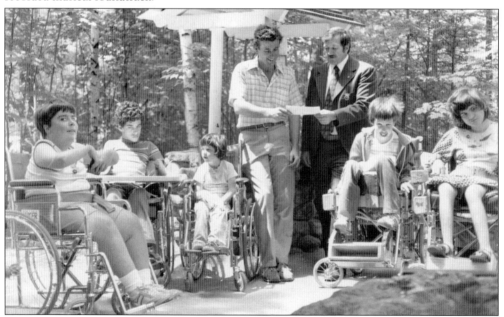

Director of educational services Robert Reffi (wearing a tie) and clients of Crotched Mountain Rehabilitation Center (Paul J., Robert C., Anne S., Maureen G., and Sherie M.) visited Story Land in 1979 to accept from Stoney Morrell the wishing well donations collected the prior season and to celebrate the 25th anniversary of the association between the park and Crotched Mountain. Some Crotched Mountain clients worked at Story Land in the 1960s.

During the late 1970s and early 1980s, immediately following the major construction projects of A Child's Visit to Other Lands and the Heritage-NH attraction adjacent to Story Land, improvements at the park continued on a smaller scale for a few seasons. Two examples of such enhancements were the 1981 additions of Grandma's Cottage in the Woods (above), with an animated wolf in the bed talking with a computer-controlled Little Red Riding Hood, and Peter Pumpkin Eater's House, a walk-in set with a sign telling the nursery rhyme. The cottage today remains in the same location near the Three Bears' House. This pumpkin house was located near the Old Woman Who Lived in a Shoe; its replacement was placed in a different location in the 1990s.

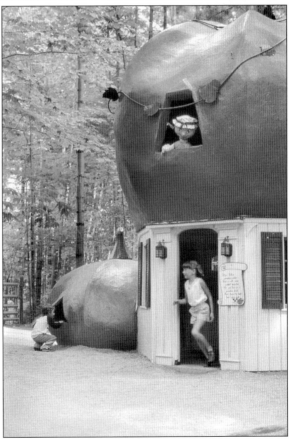

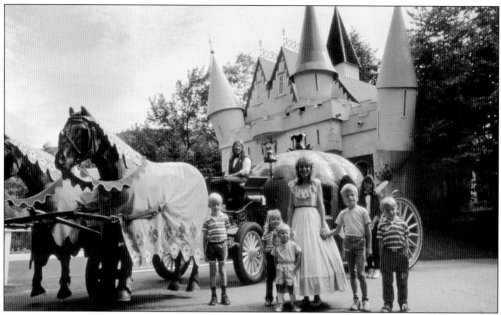

Cinderella welcomed a second-generation Pumpkin Coach in 1980. The new vehicle was motorized, as the visitor volume had increased beyond a comfortable level for live horses to continue pulling the carriage (page 31). The artificial horses covered a farm tractor–styled front-wheel assembly, which the driver steered by pulling reins rather than turning a steering wheel. Photographed in 1985, this ride was built locally and powered by a Volkswagen engine.

When real horses left the Royal Stables in 1980, the miniature ponies of the Epsom Downs horse race moved in. The new game, in which horses are advanced by rolling balls into holes, was purchased in England and arrived just in time for opening day. The game was moved into the former Villa San Jose gift shop in 2000 to make room for the Let's Pretend gift shop.

Bob Morrell poured some of the 25,000 plastic balls dumped into the former pool of Mr. and Mrs. Seal to create the Rub-a-dub-dub 12 Kids in a Tub ball crawl in 1980. Trout had used the pool after the seals left in the early 1970s, before it was cleaned and carpeted, to create Story Land's first ball crawl. It was located on the site of today's Peter Pumpkin Eater's House.

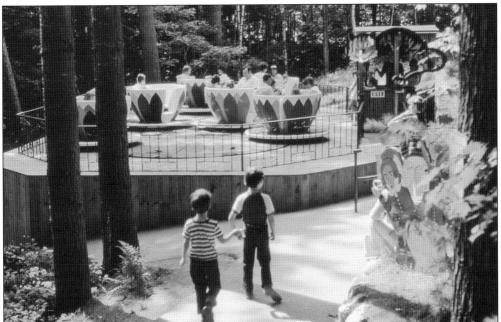

Wonderland was the theme for Alice's Tea Cups ride, added in 1982. It is a refurbished Crazy Daisy manufactured by the Philadelphia Toboggan Company and features the spinning cups twirling in a figure-eight pattern. The costumed ride operator is typically the Mad Hatter (males) or Alice herself, wearing uniforms created in the Story Land art department.

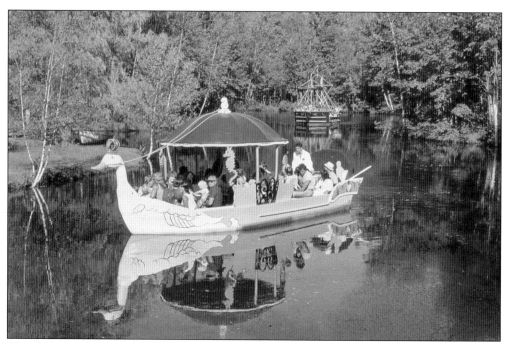

The Story Land Queen found itself sharing the pond with the Buccaneer Pirate Ship in 1981. The original Buccaneer was a 30-passenger boat built in East Boothbay, Maine, and piloted by a costumed pirate captain conducting a narrated tour. Like the Story Land Queen, the *Buccaneer* was a free-floating, self-propelled vessel steered by the captain without any sort of underwater guide rails. Unlike the Story Land Queen, passengers rowed to keep the boat moving past dangers lurking on the nearby shores. The photograph below shows the miniature paddle wheels on the side of the ship as the passengers row them.

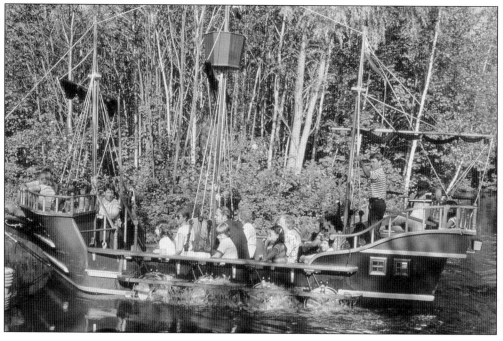

The photograph at right illustrates the rowing mechanisms used by the young passengers of the original Buccaneer Pirate Ship in 1985. A second, larger-capacity Buccaneer ship from Maine's Jimmy Jones Boatyard also included rowing handles for passengers, although the paddle wheels on the larger vessel were not as easily seen as the originals. The new Buccaneer set sail in 1989 and is still in use at Story Land today. The 1992 photograph below shows the replacement vessel on the water, while the original boat found itself beached for a temporary second life as a playground element adjacent to the ride loading area.

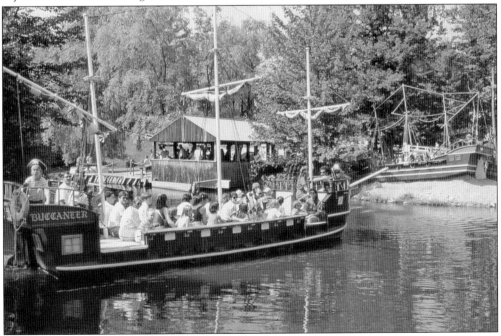

Many Story Land cast members, such as those in the 1982 photograph at left, traditionally started in the parking lot crew for their first jobs. In addition to directing traffic and cleaning, parking attendants assisted guests with dropping off and picking up their pets in the park's free kennels. For many years, when car bumper styles lent themselves to the practice, Story Land and other White Mountains attractions had their parking lot crews attach bumper signs to parked cars while guests visited. The result was a summer-long proliferation of mobile signs throughout New England and parts of Canada, as business in the region continued to grow.

Four

INVOLV-AROUNDINGS OF HISTORIC PROPORTIONS

By the mid-1970s Story Land was an established business with a two-decade history and recently completed expansion. With the theme park performing well even during the energy crisis of the early 1970s, Bob Morrell turned his attention to what he perceived as a crisis in national pride. An army veteran of both World War II and Korea, he was determined to create a celebration of patriotism to counter negativity smoldering through the 1960s and early 1970s.

Playwright and artisan Peter Stone of Alexandria, New Hampshire, had created the Let's Pretend multiscreen slide show at Story Land in 1974. Bob Morrell collaborated with him again to write a script of important moments and scenes in New Hampshire history. Stone was hired to craft a scale model and oversee construction of a new attraction designed to be what Morrell called "a totally new concept in living history." In promotional literature introducing the immersive experience engaging multiple senses, Morrell used the term 'involv-aroundings" to describe the unique new environment.

Built as a separate, indoor attraction just north of Story Land, Heritage-NH opened in July 1976 as one of two recognized state celebrations of the U.S. bicentennial. It was a walk-through presentation of 30 scenes interpreting nearly 300 years of history. Visitors strolled a winding one-way path ramped between two levels, passing through theatrical sets using state-of-the-art 1970s audiovisual technologies, mannequins, and signs to tell the story behind the settlement and development of the State of New Hampshire. Live costumed interpreters were soon added to embellish the storytelling, answer questions, and help guide visitors through the windowless, 19,200-square-foot maze of handcrafted floor-to-ceiling landscapes, building facades, and replica period interiors.

Like Story Land, Heritage-NH operated annually only during the extended summer season from May into October, between 9:00 a.m. and 6:00 p.m. daily. However, after a successful start, attendance at Heritage-NH declined steadily throughout the 1990s and early-2000s, and it survived on financial subsidies from Story Land. Anticipating the imminent sale of the family business due to his terminal illness, Stoney Morrell reluctantly decided to permanently close the attraction at the end of its 30th anniversary season in 2006.

This northerly 1960s view alongside NH Route 16 is from a spot just north of Story Land, where Heritage-NH eventually was built. The Morrells purchased the land shown front right, the former rustic cabin court of Charles Way, then sold it to finance development at Story Land in the 1960s. The Linderhof Motel was built on the site in the 1970s, and Story Land reacquired the property in 1997.

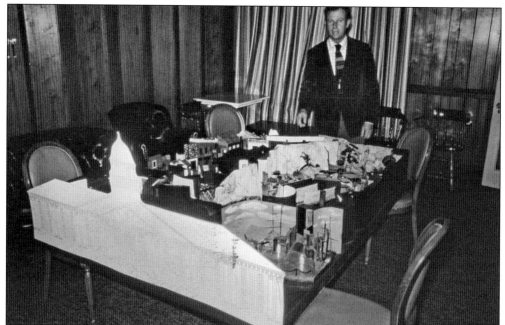

Bob Morrell stood behind a scale model of the proposed Heritage-NH tourist attraction prior to a 1975 gathering of invited guests for an unveiling of the concept's interior design. Peter Stone of Alexandria, New Hampshire, built the model and oversaw construction of the actual full-scale settings, often drafting construction plans from his model.

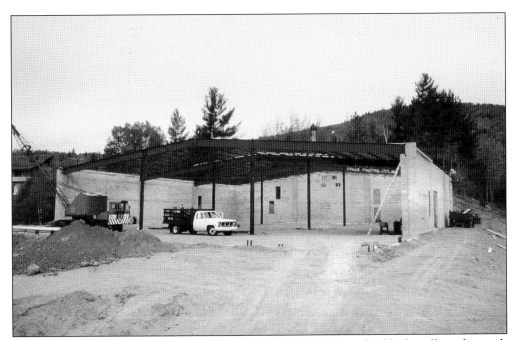

The main building of Heritage-NH was a simple rectangle of cinder block walls and a steel-trussed roof with six large supporting columns—key structural elements that had to be taken into consideration and hidden by the carpenters and artists building the intricate theatrical settings inside. This 1975 construction photograph exposes the skeleton of the project.

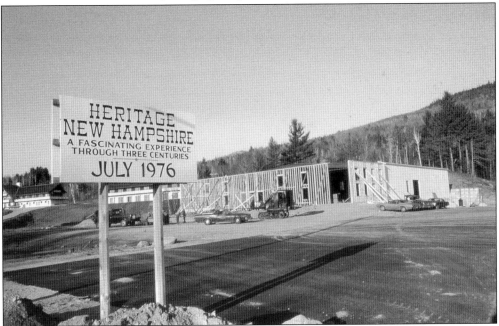

A wood-framed front lobby section was built in front of the garage-style main building of Heritage-NH. This provided opportunity to put a stately Colonial-style facade on the portion of the project facing NH Route 16. This section housed the entrance and exit, restrooms, offices, ticketing, and the original gift shop area.

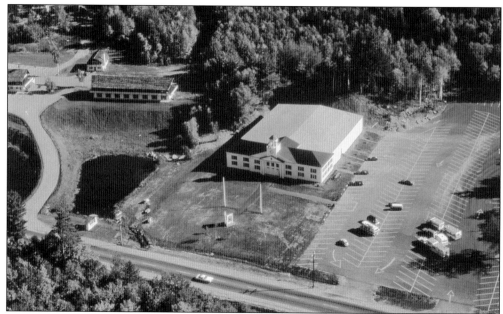

Following an estimated 28,000 man-hours of construction in about 18 months, this 1976 aerial photograph shows the newly completed Heritage-NH and its immediate surroundings. To its north (left) is the Linderhof Motel, built in 1967; to the east (behind) are undeveloped woodlands belonging to the Morrells; and to the south (right) is Heritage-NH's parking lot, adjacent to the parking lot for Story Land.

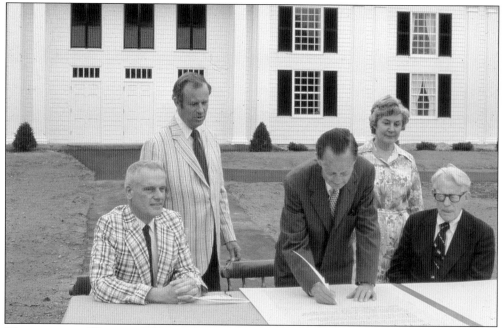

The opening of Heritage-NH in July 1976 was one of two official State of New Hampshire celebrations of the U.S. bicentennial. Three former governors signed a proclamation commemorating the grand opening. At the table from left to right are Hugh Gregg of Nashua, Sherman Adams of Lincoln, and Lane Dwinell of Lebanon; standing behind them are Bob and Ruth Morrell.

The traditional-style exterior of Heritage-NH offered no hint of the unique presentation inside. The building's 19,200 square feet of theatrical sets, special effects, and state-of-the-art storytelling technology were well-hidden by a facade occasionally mistaken for government offices or a furniture store. Still, attendance grew steadily and substantially during the first 15 years of Heritage-NH operations, approaching 100,000 annually by the late 1980s.

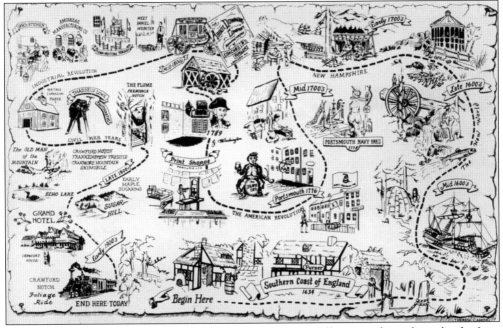

Heritage-NH was a one-way, linear, walk-through experience following a chronological order from the 1600s into the 1900s, with little renovation in its 31 years. The pathway changed elevations frequently over roughly one-third of a mile in length. This map by Madison, New Hampshire, artist Theresa Caming helped visitors recognize their progress at any point in the journey; it appeared in brochures in the 1990s.

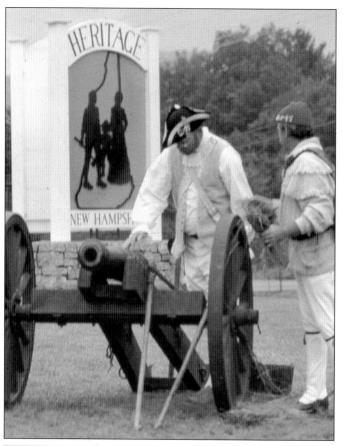

Over the course of its operations, Heritage-NH hosted numerous activities on its front lawn along NH Route 16 to accommodate groups embracing common themes and to help draw attention to the attraction itself. A September 1977 Colonial muster, complete with musket and cannon firing demonstrations, was among the first outdoor gatherings. It represented the Nichols Regiment of the Gen. John Stark expedition en route to the Battle of Bennington, Vermont. A phrase from a late-1700s letter from Stark was eventually developed into the famous New Hampshire state motto, "Live free or die." Among the lawn events and activities in later years were craft fairs, plays for elementary school groups, and public flag-raising ceremonies.

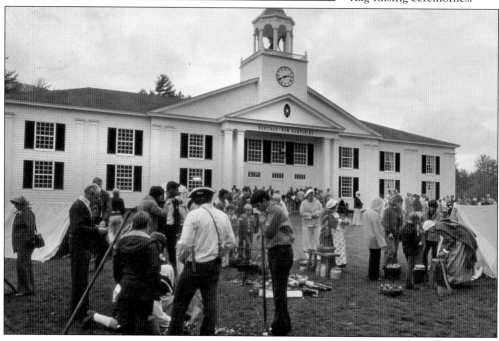

Quadrennial presidential primaries drew campaigning politicians, and the beauty of the Mount Washington Valley area and uniqueness of Heritage-NH attracted other recognizable faces. In 1977, Heritage-NH founder Bob Morrell, left, and creative collaborator Peter Stone, right, visited with young 1970s television personality Mason Reese in the Revolutionary-era Portsmouth setting inside Heritage-NH.

From 1973 to 1984, many of the world's top players and others with ties to tennis appeared in the Mount Washington Valley area for an annual international clay court tournament. In this late-1970s photograph, tennis personality Bobby Riggs (right) promotes a sponsor during a visit with Bob Morrell in the lobby of Heritage-NH.

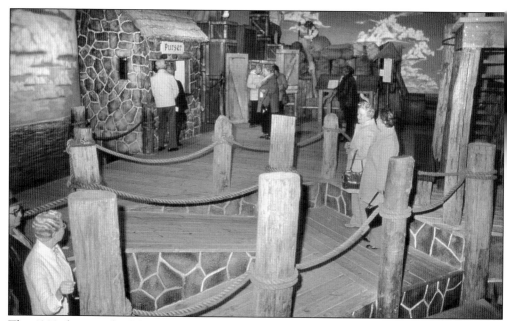

This 1980 photograph of the Heritage-NH lobby illustrates some of its unique features. Ramps took the place of stairs throughout the entire attraction, making participation available to guests using wheelchairs long before the federal government introduced the Americans with Disabilities Act of 1990. Authentic artifacts such as weathered ship ropes and waterlogged dock posts added realistic touches and touch points. Hand-painted wall murals created dramatic artistic landscape views.

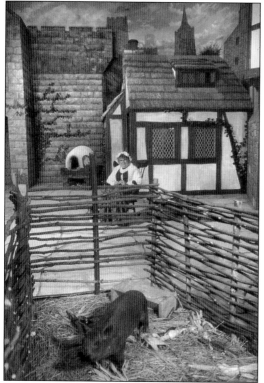

The north side of the Heritage-NH lobby originally featured a representation of the North Conway railroad station and a gift shop. In 1987, the scene was changed to a 17th-century English village to provide a consistent setting for the start of the journey through time. This 1988 photograph shows the village setting, including a costumed interpreter, cottage with thatched roof, pen with stuffed animals, and wall mural.

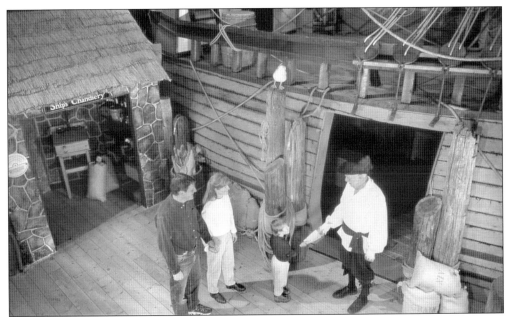

The concept of "involv-aroundings" included effects to involve all senses. In addition to impressive scenery, in 1984 the start of the 1600s voyage, shown in 1998, added recorded sounds of sea gulls and a shipyard, live creaking from a gently rocking ship, smells of saltwater and cured codfish, and conversation with the character of Capt. Harrison Barnes, who collected tickets for passage and explained passengers' roles onboard the moving ship.

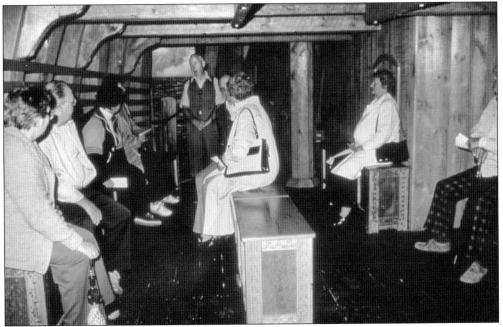

Inside the ship, illuminated by soft light through the grate in decking above, visitors were given a sense of the dark, cramped, and uncomfortable experience of a 60-day ocean voyage to a strange new world. This mid-1980s photograph shows the ship's interior. The set rocked gently on two axles driven by an electric motor below the floor, providing a realistic feel of being on water.

A three-screen slide and video presentation on a rocking ship's deck, with misting water spray and a thunderous lightning storm, led to an indoor forest setting. Proprietors Bob and Ruth Morrell and an unidentified child pose in front of mannequins at Amoskeag Falls in 1976. Approximately 8,000 leaves were wired onto fake forest trees, and 250,000 gallons of water cycled over the falls daily. Live trout swam in the creek below.

Massive pine trees used for ship masts were a source of conflict between settlers and the king's agents. Heritage-NH depicted this piece of history with a 45-foot length of 3-foot-diameter pine resting on a single wooden axle between two 12-foot wooden wheels. The tree and wheels were moved into the building before the walls were completed.

These two 1975 photographs show the final stages of the creation of the two 12-foot wooden wheels in the Heritage-NH mast pine tree display. The wheels and single wooden axle were handcrafted on-site and placed inside through a large opening left in the southern wall of the building for such purposes during construction; the opening was walled off when the attraction was completed. The photograph above shows a metal rim being removed from a fire pit for fitting on a wooden wheel. Afterward, workers hammered the rim into place for a tight fit and quality replica strong enough to bear the load of the massive pine in the display. Story Land maintenance supervisor Rodney Charles of Jackson, New Hampshire, oversaw the construction. Below, Cinderella's footbridge is visible in the background.

A ramp up to a second level led to scenes of 1700s settlements. The first of these, shown here with a costumed interpreter in 1990, originally included a mechanized mannequin built on-site that swung an axe into wood. The heavy workload wore out the mannequin, which led to the live interpreter. Eventually the character was replaced by recorded audio complemented by spotlights and triggered by a motion sensor.

Every step of the pathway was designed to engage visitors, including transitions between sets. This winter evening scene included lighting effects for a painted moonlit sky, a cool breeze from hidden fans, sound effects of a brisk wind and howling animal in the distance, and, shown in this 1993 photograph, refrigerated walls covered in ice at hand level, often surprising unsuspecting guests.

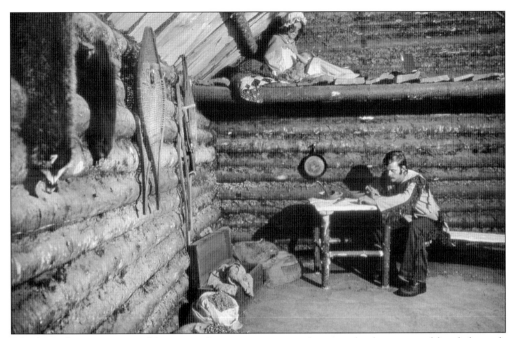

The log cabin set appeared between the winter scene and a ramp back to ground level through a barn setting and into Revolutionary-era Portsmouth. The cabin was constructed of real logs in a building project shared by Bob Morrell and his son, Stoney, while Stoney was at home during college break in 1975. This photograph was taken in the 1980s.

Near the building's center, a two-story 1770s Portsmouth streetscape was designed as a busy town preparing for rebellion. Facades and walk-through sets included the home of Capt. John Paul Jones and a tavern smelling of stale beer (occasionally poured over cloth behind a counter). This 1976 photograph shows an animatronic mannequin dumping water into the streets below while complaining via recorded message about talk of revolution without action.

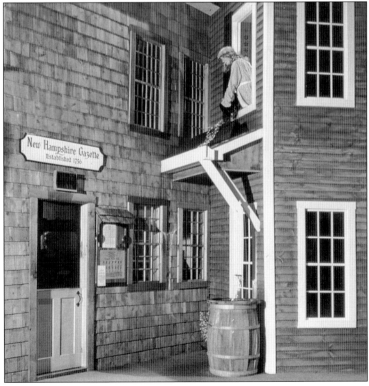

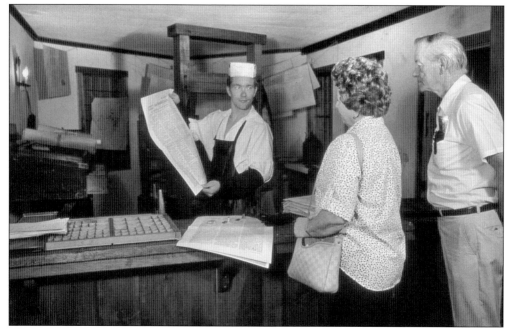

The *New Hampshire Gazette* setting, shown early 1980s, was a popular Portsmouth scene, particularly from 1995 through 2006, when a handcrafted replica Common Press annually on loan to Heritage-NH was present. Print shop interpreters handset type and printed documents just as was done in the 1700s, including broadsheet copies of the Declaration of Independence.

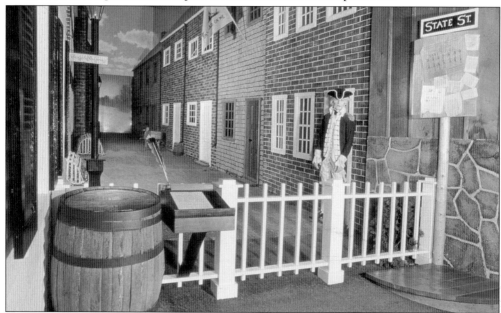

State Street in Portsmouth employed classic theater perspective techniques to create depth—building fronts constructed on decreasing scale, angled towards the back, and a plywood street painted to resemble cobblestones, inclined towards the rear. The back wall featured a painted sky; the lower portion was a movie screen with a rear-projected film depicting men marching off to battle. Photographed in 2004, the scene was essentially unchanged for 31 years.

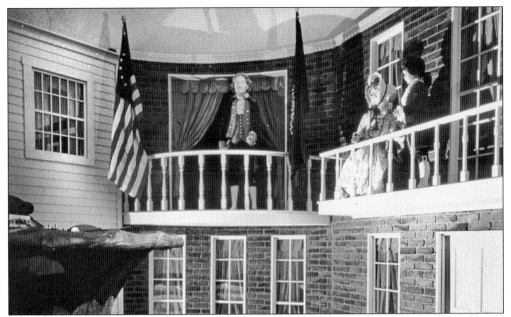

This 1970s photograph of the depiction of Pres. George Washington's 1789 public address in Portsmouth's Market Square peeks into a column housing projectors for a fireworks film shown on the domed ceiling and for the speaking face of the president. A full-faced animatronics version of Washington replaced this one in the 1990s; it stood up, gestured as it spoke, and sat down, all at the push of a button.

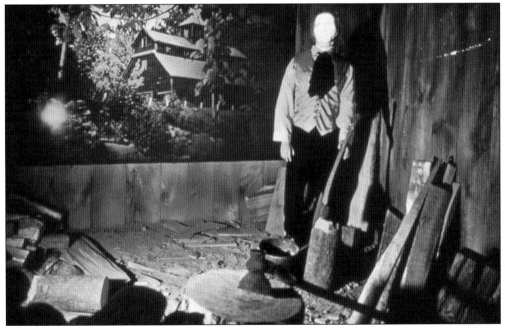

Daniel Webster was depicted in this scene, photographed in the late 1970s. A slide show synchronized to his recorded audio was shown on the screen in the background. Webster's speaking face (an actor filmed reciting the speech) was projected onto the mannequin's head; the face aged as the speech progressed, to reflect Webster's age as it related to the subjects in the audio.

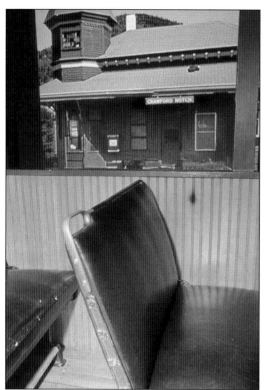

A popular experience at Heritage-NH was the tour-finale train ride featuring real train seats in a replica passenger car interior, seen here in 2004. Slides of actual scenery through Crawford Notch, from each side of the rails, were pieced together on film projected onto screens set back several yards from either side of the car. A train soundtrack complemented realistic motions of the mostly stationary car, jerked by electric motors underneath.

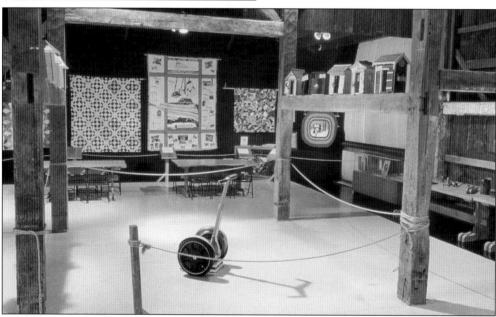

Additions expanded the 1980s and 1990s footprint of Heritage-NH, including a glass silo for sunlight in the 1700s woods, an 1850s kitchen, and a gift shop. An 1803 barn dismantled in Denmark, Maine, was reassembled as exhibit space. Photographed in 2004, it housed many displays, and from 2003 to 2006, guests test-drove a Segway Human Transporter direct from the New Hampshire factory. This Segway actually climbed the Mount Washington Auto Road.

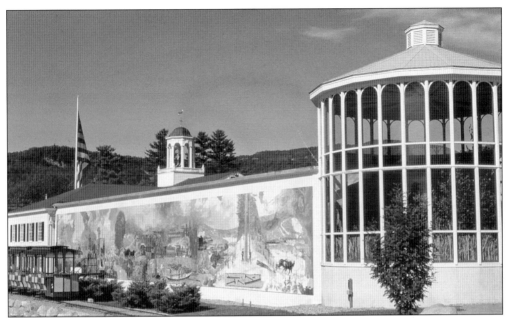

In 1990, Heritage-NH unveiled a state history mural along the building's exterior southern side. It was researched and designed by Jackson, New Hampshire, artist Veikko Hurme with help from Conway, New Hampshire, artist Ernie Brown; both had painted key portions of scenery inside the attraction. Measuring 16 feet by 120 feet, it was displayed year-round through 1999. The above 1990 photograph shows the mural stretching from the rear atrium addition to the wood-framed building front; the trolley alongside was used to exhibit the painting to tour groups. After exposure to a decade of sun and weather destroyed the mural, Brown recreated his and the late Hurme's artwork at about one-quarter scale. The smaller version, in the 2004 photograph below, was exhibited in the barn addition to Heritage-NH and traveled to off-site locations.

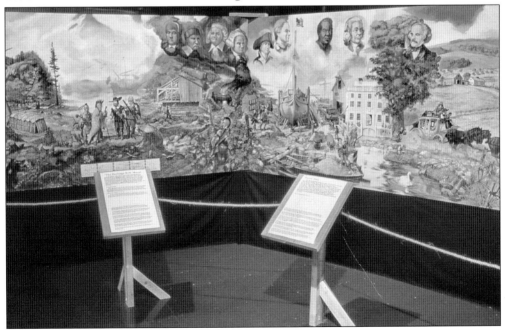

Heritage-NH flew the state's largest U.S. flag, measuring 30 feet by 50 feet and weighing 75 pounds. Other features added to the lawn over the years included four whirligigs measuring up to 18 feet tall made by craftsmen Peter Stone and David Norton in 1986, a restored antique pickup truck, and a covered bridge built by Arnold Graton of Ashland, New Hampshire, in 1999. This photograph is from 1993.

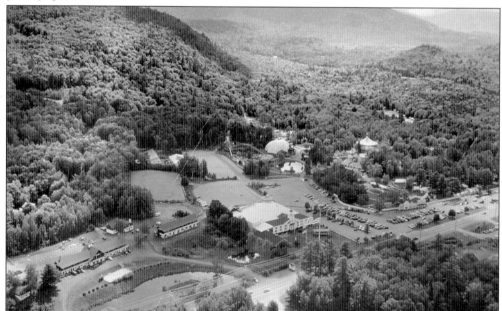

This 2000 aerial photograph shows how much Story Land had grown geographically since 1976 when Heritage-NH opened. With annual attendance more than doubling at Story Land during that time span, facilities for the park had engulfed Heritage-NH, which had seen a steady decline in attendance since the early 1990s. Heritage-NH closed permanently at the end of its 30th anniversary season in October 2006.

Five

THE PURSUIT OF THE UNIQUE FACTOR

In its formative years, Story Land was a constant and needy presence in the household of Bob and Ruth Morrell. It was conceived as the virtual middle child between the births of daughter Nancy and son Stoney. The "creative safari" replaced the Morrell family vacation in 1958, when a Disneyland trip served to define a standard of quality that Story Land emulated to help ensure its survival. Essentially all family travels after that yielded an idea or feature that was eventually adapted to benefit Story Land guests.

As Nancy matured, she chose a career outside of the family business. For several years after graduating from Dartmouth College, Stoney also pursued other interests. By 1982, however, he had come to admire the unusual opportunities and fulfilling satisfaction provided by operating the park, and he returned to join his parents in the business. As a team, the three shared a passion for quality service, community involvement, and an unending pursuit of what Bob called the "unique factor"—a customized twist to every undertaking, yielding something special found only at Story Land.

Near the end of the 1980s, Story Land undertook an ambitious growth program, once again expanding the park boundaries and adding major new rides and unusual play features. Stoney blended his mother's business sense and what he called his father's "constructive restlessness" to help guide Story Land to higher levels of creative and business success, both overlapping and following his parents' involvement.

The pursuit of the unique factor strengthened over time. In the early 1990s, a storage building was converted into the Story Land "magic shop," where animatronics experts and artists were assembled to collaborate with other cast members to design and fabricate top-quality features on-site; numerous one-of-a-kind items were created in this facility over more than 15 years. A state-of-the-art maintenance building also was created to accomplish professional maintenance and development projects in-house even during the harsh winter months. The facility includes separate work spaces and advanced equipment for rides and vehicles, audiovisual controls and components, computer graphics and sign production, high-tech coatings and painting for props, and sewing for costumes.

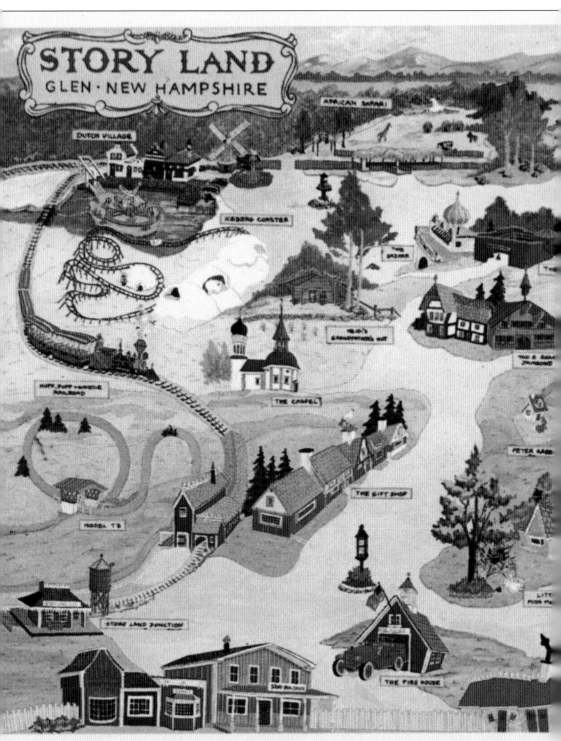

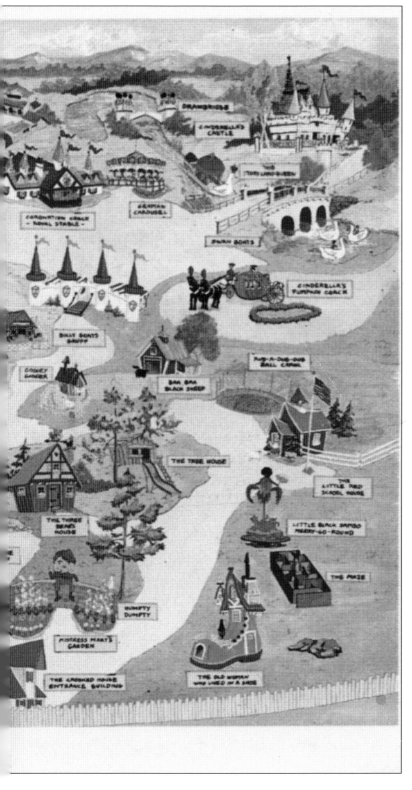

The 1980 Story Land park map, compared to 1956 (pages 12 and 13) and 1960 (pages 36 and 37), illustrates the tremendous geographic growth represented by the addition of A Child's Visit to Other Lands, plus some smaller enhancements such as the maze and the ball crawl. The park's pricing structure was simplified in 1979 when payment for individual rides was eliminated, and for the first time everything was included in the $5 price of admission for ages four and older. Season pass sales started in 1988 and originally were valid only on the three least-busy days of the week at the time—Friday, Saturday, and Sunday. Heritage-NH, Story Land's sister attraction, required a separate admission fee and was located further left of the area represented by this map.

Throughout the park's growth, Story Land's original features continued to entertain guests. Little Miss Muffet, photographed in 1975, had been in this same location since 1954 (page 22). Sitting on the tuffet triggered the spider to drop. The background building, with a large "WC" (for water closet) on its sign, housed restrooms.

A popular new face photographed in 1985 was the lion's head drinking fountain across from the Moroccan Bazaar in A Child's Visit to Other Lands. Today's visitors will find the fountain in this same spot, and often children are unable to resist stopping for a sip of water, thirsty or not.

Ruth and Bob Morrell pose in front of Heritage-NH in 1976. The founders of Story Land and Heritage-NH were also the only two executives of the family business for its first quarter-century. Daughter Nancy had moved away and started a family; son Stoney, nine years younger, was off to college and considering alternative occupations.

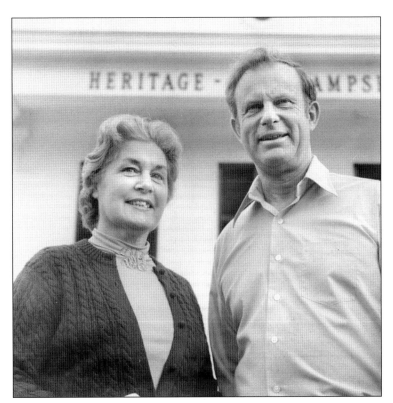

For several years after college, Stoney Morrell, left, traveled internationally and worked in the western United States before returning to join Ruth and Bob full time in 1982. "I saw that there existed here an opportunity to make statements of values and aesthetics, of family togetherness, to share a message and have some fun," he said in a 1990 address to the Newcomen Society of the United States.

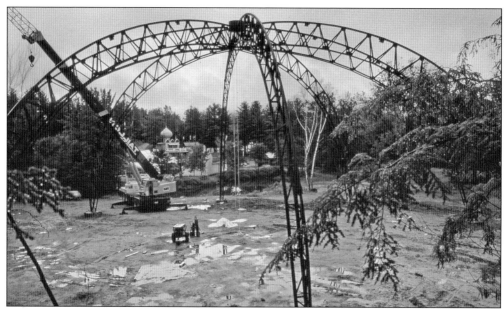

After a year of study and preparation, Story Land announced in 1981 that it would add a new, original, state-of-the-art dark ride. Inspired by Disney's Space Mountain coaster and loosely based on the 1865 Jules Verne novel *From the Earth to the Moon*, in which travelers blast into space with a cannon, it would be housed in a fabric-covered dome 50 feet tall and 124 feet wide. Bob Morrell had seen a similar structure in a Florida cow field and was determined to add one to the park. The interior of the white fabric roof was painted black, and two of the creative collaborators on Heritage-NH, artisans Peter Stone and David Norton, were hired to create the story line and the scenes inside. The dome took shape in 1981. The skeletal steel of the huge cannon was ready in winter 1982.

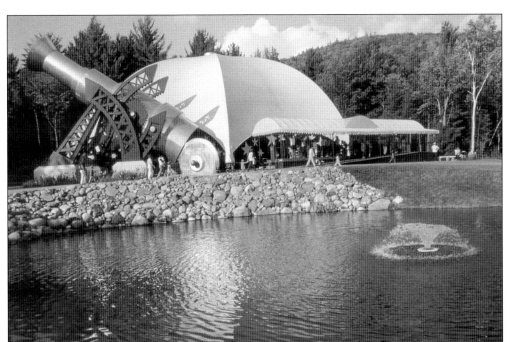

Space Fantasy, later renamed Voyage to the Moon, officially opened in June 1983 after nearly three years of engineering and construction. Gov. John Sununu shared the first five-minute voyage with Bob Morrell in the bullet cars built by Bradley and Kaye of California. Each car had speakers to broadcast sound effects triggered by an antenna underneath, computer-synchronized with lighting effects. The cars moved slowly through the cannon on a chain-driven conveyance into the darkened dome, slowly winding back down through a series of fantasy scenes such as a candy land and a polka dot sea, each populated by friendly, animated, imaginary creatures. Story Land's only dark ride operated for about 15 years before the dome was converted to the Loopy Lab play area in 1998. The original blackened cloth cover was replaced by an all-white one in 2008.

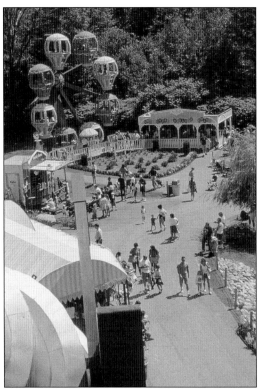

The Great Balloon Chase brought a Ferris wheel with family-sized cabins to Story Land in 1985. The original version was replaced in 2002 with a new, more efficient model equipped with a wheelchair-accessible cabin; both were manufactured by Zamperla of Italy. This 1994 photograph includes the portable Melody Farms animated show (left center) that appeared at both Story Land and the Eastern States Exposition in Springfield, Massachusetts, for many years.

Story Land celebrated its 35th anniversary with the unveiling of a bronze sculpture entitled *Winds of Imagination* in honor of Bob and Ruth Morrell. It was placed in its permanent location pond-side near the Great Balloon Chase in 1989 and remains a fitting tribute to the spirit of the park and its founders.

In addition to being a theme park manager, Stoney Morrell was an aspiring farmer and an environmentalist who believed Story Land could educate as well as entertain children. He developed the Green Garden Variety Show, later renamed Farm Follies, which replaced the Ted E. Bear Jamboree in the hilltop theater in 1985. The show featured a live scarecrow character telling the story of how a garden grows, with the help of singing animated farm animals and vegetables on a musical soundtrack. In the above photograph, Bob Morrell (left) and Stoney checked the progress of production at Advanced Animations. Farm Follies moved to a new theater in the barnyard section of the park in 2005.

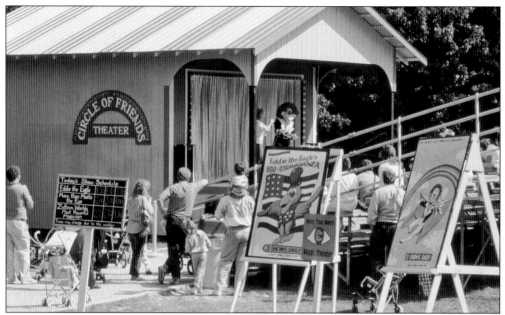

The Circle of Friends Theater opened in 1987 where exotic animals previously had roamed in the African Safari ride (page 56). The 400-seat theater hosted the first all-live-action shows to be performed at Story Land, with three productions each playing three times daily: Zoltron, the World's Most Powerful Magician; Eddie the Eagle, learning to fly; and More than Meets the Eye, a juggler/mime/magician.

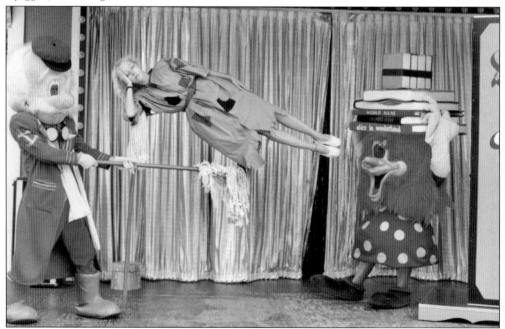

The lineup of shows varied over the years at the Circle of Friends Theater. Professor Bigglestep (left) and his sidekick, Bookmark, performed their own brand of magic in 1988. The Bigglestep character was revived shortly after his show ended, as the title character of the Loopy Lab play area and show that moved into the former Space Fantasy dome in 1998.

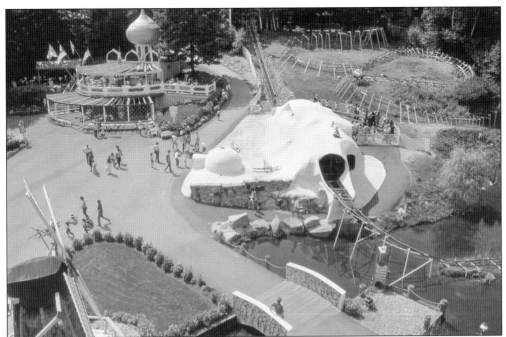

The Ice Berg Coaster (seen above in a 1985 photograph), with its loading station themed with an igloo and iceberg, operated at Story Land from 1975 through 1986. It was replaced in 1987 by the Polar Coaster designed by O. D. Hopkins Associates of Contoocook, New Hampshire. The cars were created by Bradley and Kaye of California in the shape of walruses. The Polar Coaster's two trains each consisted of two cars for a capacity of eight passengers; a middle car was later added to each to raise the capacities to 12 riders at a time. The upper deck of the Moroccan Bazaar building in the background was later converted into the Tales of Wonder Theater in 1993.

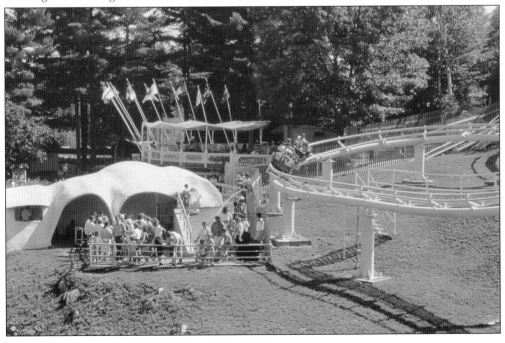

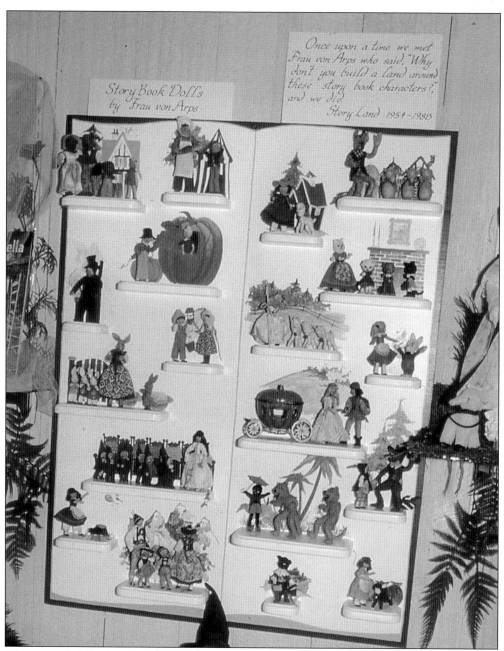

The original dolls that served as the inspiration for Story Land went on display inside a glass showcase in the Storybook Corner gift shop during the park's 35th season in 1988. They were made by Frau Edith Von Arps, from Nuremberg, Germany, who suggested in 1952 that the Morrells build a village based on storybook characters. The dolls each measure just a few inches tall and are made of cloth and felt, with lead feet and bendable wire bodies. In the display, the dolls stand on tiny shelves in front of painted backgrounds depicting scenes from the respective stories. Characters within the set included Cinderella, Goldilocks and the Three Bears, Jack and Jill, Little Bo Peep, Little Miss Muffet, Peter Pumpkin Eater, and the Three Little Pigs. During the 1950s, Von Arps dolls were sold in the Story Land gift shop.

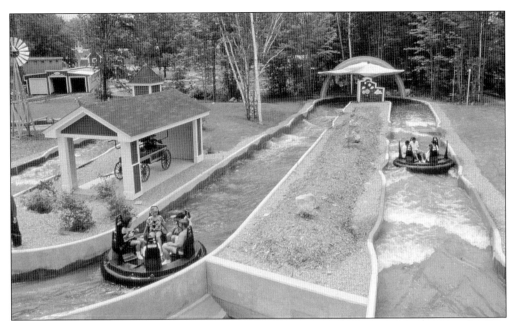

The mystical waters of Victorian-themed Dr. Geyser's Remarkable Raft Ride began flowing through its 900-foot concrete river in 1989. The ride was made by O. D. Hopkins Associates of Contoocook, New Hampshire, with numerous additional squirting and misting features designed and built at Story Land. By 1991, a footbridge over the train tracks near the tunnels (background left) connected a new pathway to the front of the park.

Soaking geysers of water created by blasts of compressed air are the main attraction of Dr. Geyser's Remarkable Raft Ride. Many smaller splashes also surprise passengers along the way, such as the leaking water tank visible in this 2005 photograph. Once used to help fuel the park's steam train (page 35), the simple tank was recycled to complement the high-tech ride.

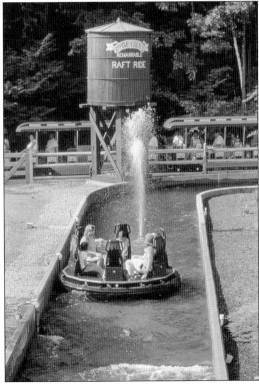

In addition to new state-of-the-art amusement rides, Story Land continued to regularly add simple, low-tech features that helped enhance the fun family atmosphere and create lasting memories. A 1988 renovation of the South of the Border section led to this often-repeated pose of children behind bars (actually flexible rubber hoses) in the Los Bravos Jail.

In pursuit of the "unique factor," Story Land often used local talent for in-house creative projects, including the recorded sounds and songs heard throughout the park. Bartlett, New Hampshire, students recorded the musical soundtrack for new Tales of Wonder stage shows in 1994 at West Side AV Studios. From left to right are composer Sharyn Ekberg, Nicole Welch, Alicia Sierpina, Stacey Spalding, Melissa Mullineaux, Lyndsay Santeisanio, Alicia Sparti, and Leigh Richardson.

The Swamp Shoot squirting range was created by Story Land near the Space Fantasy dome in 1989. Guests positioned oversized frogs to squirt a stream of water through matching holes in sliding transparent panels. The range moved onto Heidi's hill in the mid-1990s and eventually was replaced in 2002 by the Cuckoo Clockenspiel ride.

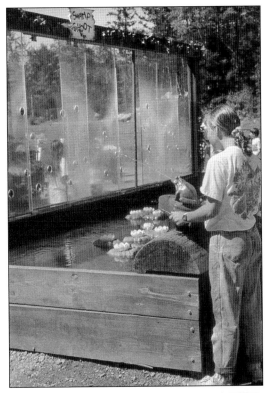

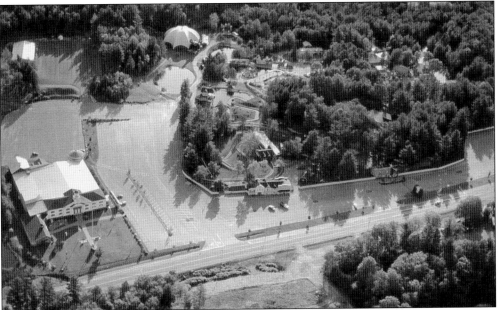

Trees near the Crooked House entrance in this 1992 aerial photograph cloak the original portion of Story Land, while recent additions are more visible. At lower left is Heritage-NH; the small upper left garage became the magic shop in 1993. The Bamboo Chutes flume ride was built in 1993 in the wooded section left of the dome. The Circle of Friends Theater is visible to the right of the Dutch Village.

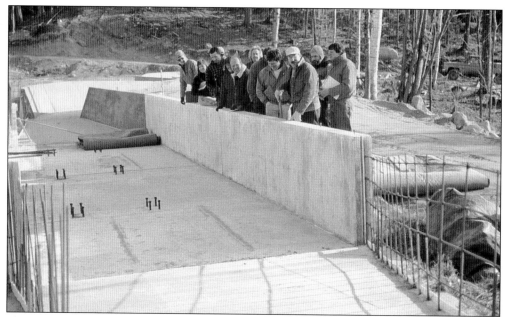

Year-round cast members collaborated on and often toured progress of major projects such as the Bamboo Chutes loading station in winter 1992–1993. Seen from left to right are John Lacasse, Victoria Drew, Daniel Drew, Marion Owen, Robert Owen, Robert Marquis, Curtis Gordon, Stoney Morrell, Christopher Marchioni, and Robert Clark. The Oriental-themed flume ride opened in 1993.

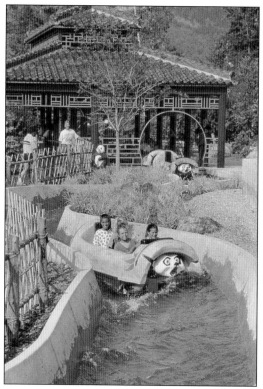

The Bamboo Chutes flume ride was built by a large group of area contractors and craftsmen, led by ride manufacturer O. D. Hopkins Associates and the panda bear boats fabricators at R. P. Creations of Berlin, New Hampshire. The construction materials included over 7 miles of wiring, 23 tons of steel, and 1,500 tons of concrete at a total cost exceeding $1 million in 1993.

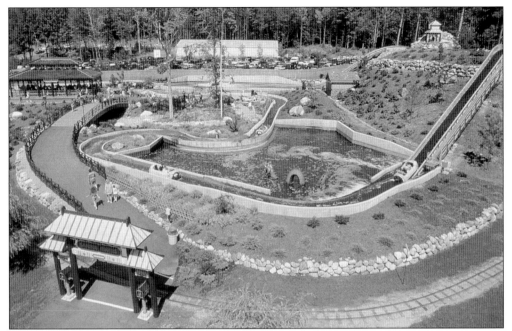

Like many rides and features at Story Land, Bamboo Chutes was designed to work within the natural setting and environment. The lift and drop for the flume ride topped off on a natural hillside area of the park. Plants used in the landscaping were researched to visually complement the theme and to ensure their survival in the local climate.

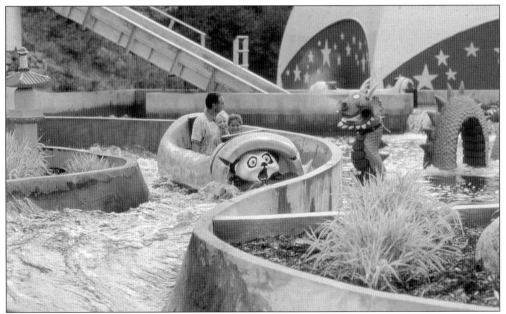

The mist-spraying dragon of Bamboo Chutes was one of the first animated elements to be designed and built at Story Land's new one-of-a-kind magic shop fabrication building in 1993. With it and the addition of an adjacent state-of-the-art maintenance, audiovisual, and graphics building a few years later, the park efficiently created numerous unique features throughout the 1990s and early-2000s.

Taber's Filling Station was added near the Antique Cars ride in 1993. It was an animated show refurbished from an automobile manufacturer's trade show display with a new soundtrack featuring a song and dialog about Heritage-NH. The show was removed after 2006 when Heritage-NH closed, and the filling station was partially reassembled within the Antique Cars track. The name Taber was a surname on Ruth Morrell's side of the family.

A playground called For Little Dreamers was opened in 1991 just south of the Schoolhouse. It included numerous familiar nursery rhyme diversions for children, such as the full series of activities beginning with, "one, two, buckle my shoe." A new ball crawl built in this section created room for the current Peter Pumpkin house nearby.

In 1994, the Circle of Friends Theater (page 98) was removed and the area was redeveloped into the Friends Around the World Food Fair and World Pavilion. In keeping with the themes of A Child's Visit to Other Lands and a Circle of Friends, the World Pavilion dining area was built as an open-sided circle measuring 100 feet wide and ringed by cutouts of children with joined hands. A 10-foot globe was placed above the tensioned-fabric roof of the steel structure. A 2,400-pound, 3-foot granite sphere visible in the center courtyard in the 2004 photograph below is supported on a thin layer of water and spins with the touch of a child's hand.

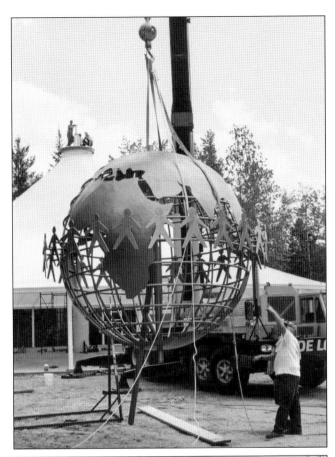

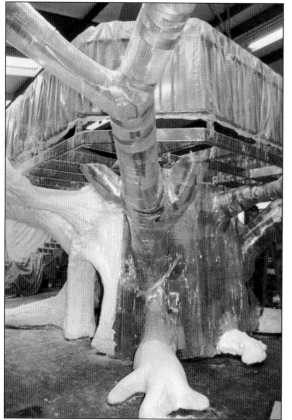

Story Land replaced its original 1960s Tree House with a new one fabricated at the park in 1995. It measures 28 feet across the branches, supported on a 10-foot-diameter trunk with a staircase inside leading to a second-level deck and slides. Animated humming birds and a bee hive were added on the branches, while a grandfatherly face in the trunk's bark quizzes children with riddles. The massive steel structure is encased in industrial-grade foam. A wall was removed from the magic shop where it was built to move the 17,000-pound tree out instead of cutting branches and reattaching them as originally planned. The Tree House is located near the Old Woman Who Lived in a Shoe where the maze (page 49) once stood.

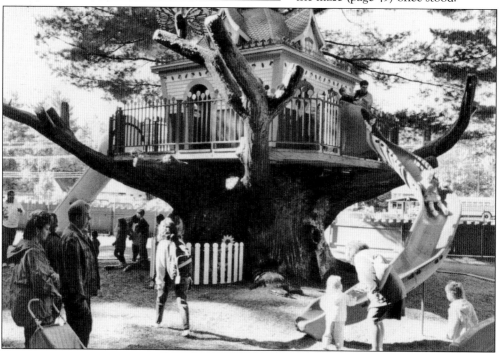

Six
A Product Taken Home in the Heart

Story Land was built idea by idea over the course of more than half a century, avoiding any real master plan as a guide. Its development, Stoney Morrell once said, was like assembling a giant jigsaw puzzle, but without a picture on the box to show what it should look like in the end. The park's deliberate and collaborative approach allowed timeless features to be retained and enhanced over the decades, while ensuring that new additions were meaningful to contemporary audiences.

Development at Story Land was guided by three principles over more than 50 years: safety, fun, and aesthetics. The philosophy emphasized that construction is not about building a structure but about painting a picture, and all guests should feel comfortable that they look good in the picture. The reasoning behind this outlook, as Stoney explained to a gathering of the Newcomen Society of the United States honoring Bob Morrell in 1990, is that a visit to Story Land is "a product people take home not in their pockets but in their hearts."

Story Land celebrated its 50th season in 2003 by opening another new section of the park—the barnyard area—with two new rides, a food stand, a theater completed the following year, and room for growth in the future (including an island where the Royal Hanneford Circus produced a multiple-season run under a big-top tent beginning in 2008). The park's new Crazy Barn was the only ride of its kind in the country, the Tractor Ride the only one of its kind in the northeastern United States, and the Farm Stand featured baked treats and fresh fruits for a change of pace from regular theme park menus.

With its unwavering focus exclusively on families with young children, pursuit of the unique factor, philosophy of taking care of people, and culture of safe, smooth, smiling, spotless service, Story Land has remained popular into the 21st century. The park's history serves as its blueprint for success in the future, as an enchanting environment where children and parents make lifelong memories while taking time to play together.

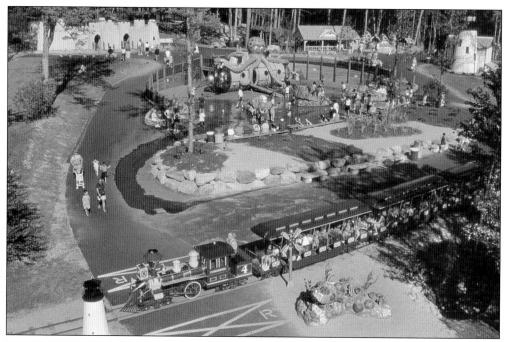

The Oceans of Fun spray-ground opened in 1996 with unique features created at Story Land: a 40-foot-long submarine with sophisticated squirt guns, several squirting corals, a maze with a sandbox, and a lighthouse food stand. The 20-foot octopus was also designed in-house. This expansion reflects and illustrates the creative collaboration between cast members of various Story Land departments: art, audiovisual, maintenance, operations, magic shop, food service, and others.

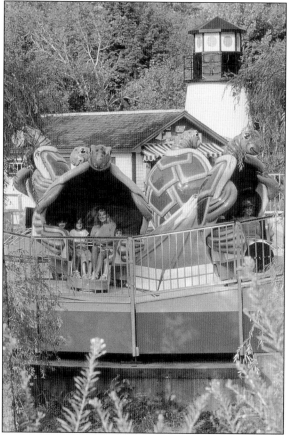

The Turtle Twirl was the featured amusement ride within Story Land's Oceans of Fun expansion in 1996. The ride is a classic Tilt-a-Whirl made by Sellner Manufacturing of Faribault, Minnesota, customized with turtle-shaped cars designed and requested by Story Land; the company now sells several customized models, including the turtle. This photograph was taken in 2005.

By the mid-1990s, the high maintenance costs and low capacity of the Voyage to the Moon ride led to consideration of alternative uses for the domed structure. Reviving a character from the park's 1980s Circle of Friends stage shows, the building was transformed into Professor Bigglestep's Loopy Lab. In 1998, one side was dedicated to an indoor playground full of foam balls, giant vacuums and hoses, and compressed air cannons.

The second half of the Loopy Lab was converted into a theater that opened in 1999. A live-action show created in-house featured cast members as Professor Bigglestep's assistants attempting to launch a rocket fueled by molasses and corn. Audience participation was mixed with numerous audiovisual special effects, culminating with an eruption of yellow foam balls from atop a silo as the launch fizzled into a theater-load of foam-ball popped corn.

A new Peter Pumpkin Eater's House in the late 1990s replaced the original version (page 65) in a spot once occupied by the seal pool. Like most of the park's unique attractions, it was built in-house. Story Land's investment in maintenance, fabrication, painting, and art facilities and equipment throughout the 1990s and early 2000s, staffed by creative and talented teams, allowed the park to continually upgrade and improve timeless features.

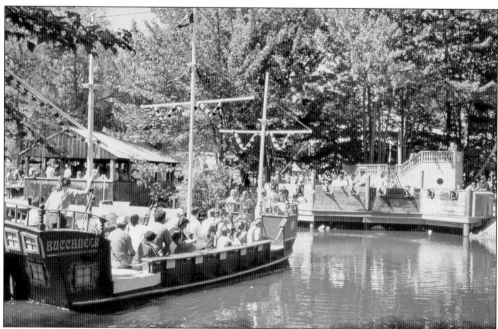

A new pirate playground area, photographed in 2000, replaced the original, which featured a scuttled boat (page 69). The new playground was larger and included more elements for participatory play, such as a fortress and a replica ship with slides, plus water cannons to take aim at the Buccaneer as it approached the dock.

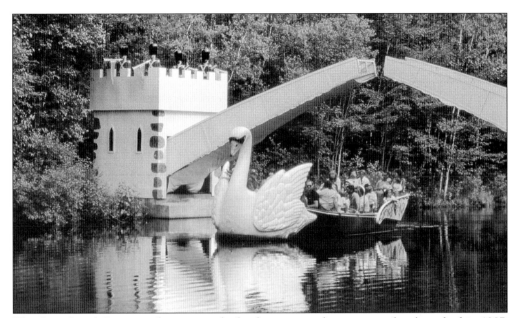

The Story Land Queen took on a new look when a second-generation ship launched in 1987. Measuring 29 feet from beak to tail feather, the boat was built in Naples, Florida, with a large swan added to the bow at Advanced Animations in Vermont. Before Story Land built its own "magic shop" in 1993, Advanced Animations fabricated several unique and animated features added in the 1980s. In the above 1996 photograph, passengers help open the drawbridge (also on page 41) with a collective "Open Sesame." Below, Butterfly Island was enhanced in 1997 as the centerpiece of the voyage. As the boat cruised by, passengers helped the island transform from quiet and gray into a lively and colorful oasis. Prince Charming waves from atop his horse to the left of the harp.

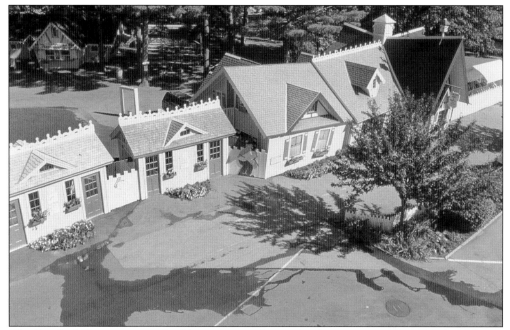

The Crooked House entrance building continued to evolve from its original c. 1960 form (pages 38 and 52). By the time of this 2000 photograph, the original portion had been renovated to include an office upstairs and a first aid station on the ground floor. Auxiliary entrances were added in the small buildings on the left to accommodate attendance growth.

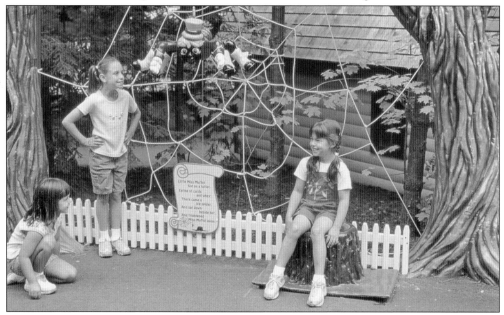

Little Miss Muffet opened in a new setting in 2002 behind Grandma's Cottage near the Little Dreamers nursery rhyme section. New man-made trees were created at Story Land, and the spider continued to drop when someone sat down beside it. The move from its longtime setting at the front of the park (pages 22 and 92) was necessary after branches were trimmed from the original tree.

The original Little Miss Muffet tree (page 22) was home to the nursery rhyme spider and its web from 1954 through 2001. When an annual inspection of the park's trees indicated the branches on this one were becoming fragile, the set was removed and a decision was made to preserve the tree in a safe and attractive way. Throughout winter and spring of 2001–2002, Massachusetts sculptor Justin Gordon collaborated with Story Land artist Donna Howland on a colorful tree sculpture that quickly became a favorite spot for family photographs. In addition to the Three Bears, Peter Rabbit, and Cheshire Cat, when viewed from the side observers see a small rendering of the state symbol, the Old Man of the Mountains.

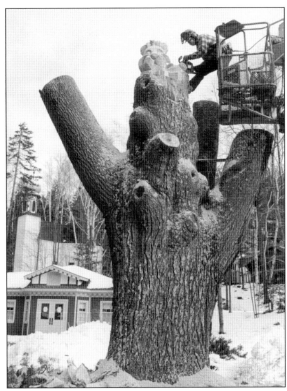

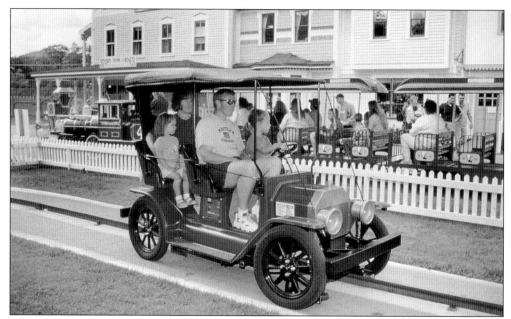

New antique cars arrived in 2000. The third generation of the ride was the first fleet of cars not built locally; they were made by Chance Rides Manufacturing of Wichita, Kansas. The new vehicles were powered by rechargeable batteries and promised two state-of-the-art enhancements over the previous fleets: the electric motors eliminated the use and fumes of gasoline and collisions between cars were greatly reduced using sensor-triggered anticollision devices.

The Story Land wishing well moved to its third location in 2005. Originally on the back side of the hill below Heidi's House (page 19), it was later moved near the chapel (page 64). The 2005 move to the base of the hill made room for a sloped pathway, meeting Americans with Disabilities Act standards for wheelchair access to the many features along the hilltop.

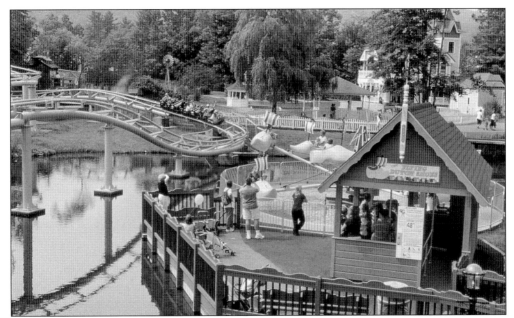

Meticulous maintenance and safety practices have led to Story Land guests enjoying some of the park's original rides for decades. Photographed in 2007, the Flying Dutch Shoes operates daily in a much busier—and safer—environment than its beginnings in the mid-1970s (page 61). Nearby, both Polar Coaster trains added third cars to increase capacity from eight to 12 passengers each, and safety was enhanced with upgraded brake components.

Today's Slipshod Safari tour, shown in a 2001 photograph, has continued much as the original African Safari (page 57) began, although there are a couple of new replacement tractors and no live animals roam the grounds anymore. The caged passenger car has been a favorite for generations of Story Land visitors.

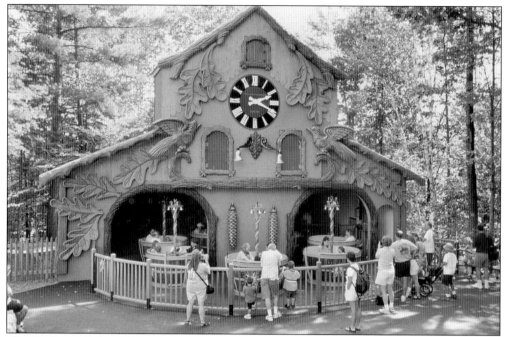

The Cuckoo Clockenspiel opened in 2002 on the hillside across from the Polar Coaster in a spot formerly occupied by Soggy Froggy and the Fort (page 63). The ride's individually spinning tubs rotate through a giant clock with moving gears, gnomes, and equipment inside. Soldiers and a cuckoo bird pop out of the doors in front. Wisdom Industries of Colorado manufactured the park-designed ride mechanisms; all other features were created at Story Land.

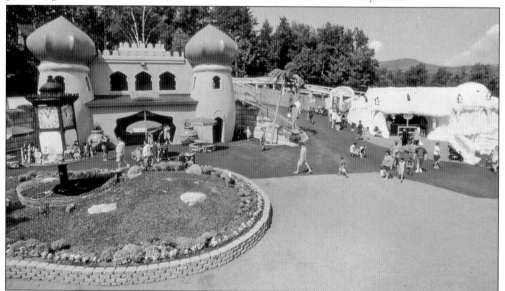

The salmon-colored stucco of the Flying Carpet Sandwich Oasis, topped by inflatable blue spires, replaced the former Bazaar (pages 55 and 99) and Tales of Wonder Theater building in 2005 with a lunch menu and upstairs dining room. Ice cream service was moved across the path to the Whistle Stop station, and a replacement stage space opened in the hilltop theater as Farm Follies moved to its new barnyard location.

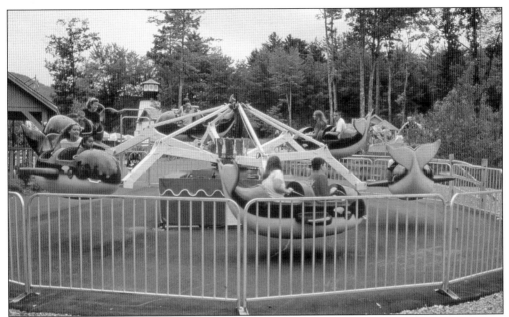

The Whirling Whales in 2002 became the second ride in Oceans of Fun. Built as a portable ride by Wisdom Industries, it operated adjacent to the Turtle Twirl before being moved across from the spray-ground, making room for the Flying Fish. A new version of the Great Balloon Chase Ferris wheel from Zamperla of Italy was a third new ride (along with the Cuckoo Clockenspiel) at Story Land in 2002.

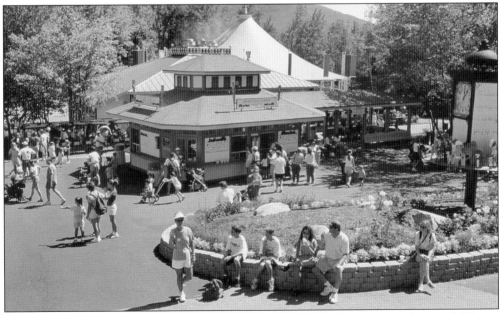

The Whistle Stop Diner and train station replaced the Lubumbashi Station and original African Safari loading station (page 57). Opened in 2000, it originally served lunch items such as baked potatoes. When the Flying Carpet sandwich stand opened in 2005, the Whistle Stop switched to ice cream. A Story Land historical mural painted by art department cast members was placed on the side of the building facing train passengers.

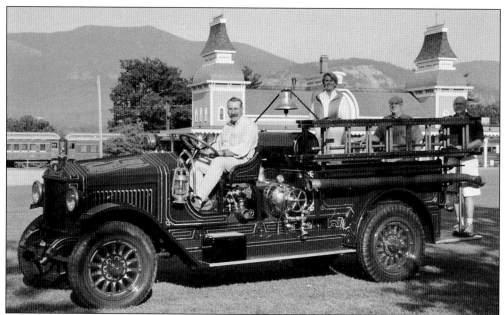

Story Land celebrated its 50th season and anniversary in 2003–2004. Along with a cast member reunion and other activities, the occasion was marked by the return of the fully restored Freddy the Fire Truck to North Conway's Schouler Park in 2003. In a pose reminiscent of 1954 (page 23) are, from left to right, Stoney Morrell (in place of his late parents), Nancy Morrell, Glenn Saunders, and Roger Jones.

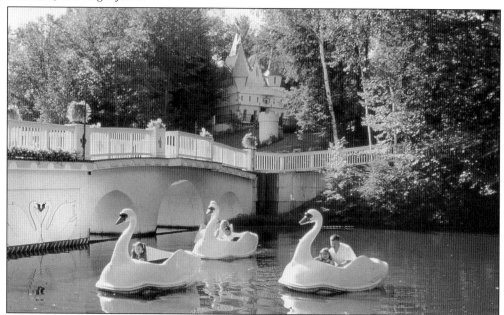

Cinderella's Castle area continued to be one of the signature scenes of Story Land into the 21st century and received attention to keep it looking and functioning appropriately. Photographed in 2004, the Swan Boats had been completely renovated by R. P. Creations of Berlin, New Hampshire, the prior year. The footbridge was completely rebuilt in 2001, and the castle exterior received new stucco and paint in 2005.

A farm-themed Tractors ride opened in 2003 during Story Land's 50th season. Manufactured in Italy by SBF Rides, the colorful vehicles roll along a concrete track guided by a center metal rail that conducts power to the electric motors through brushes in the undercarriage. At the time of its installation, Story Land became the only park in the northeastern United States with such a ride. As shown in the photographs from 2003 (above) and 2004 (below), the park added several thematic accessories along the way, ranging from animated man-made vegetables, to a colorful barn building, to real vegetables planted and harvested annually.

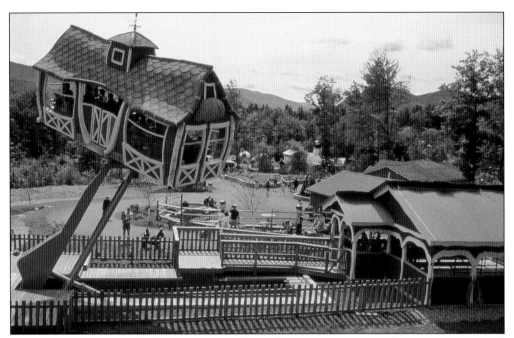

Rising and spinning high above its surroundings, the Crazy Barn created an impressive visual welcome to the new barnyard section when it opened in 2003. Installed alongside the Tractors ride and manufactured by Preston Barbieri of Italy, it was the only ride of its kind in the country when it opened at Story Land.

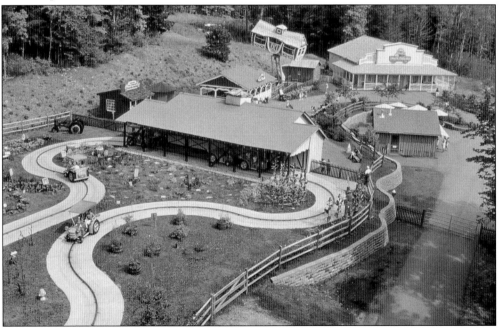

Photographed in 2007, the barnyard area was the last major expansion at Story Land under ownership of the founding Morrell family, although other improvements and enhancements continued through the sale of the park. With its attractive and unique features focused on families with young children, the barnyard remained true to the park's origins.

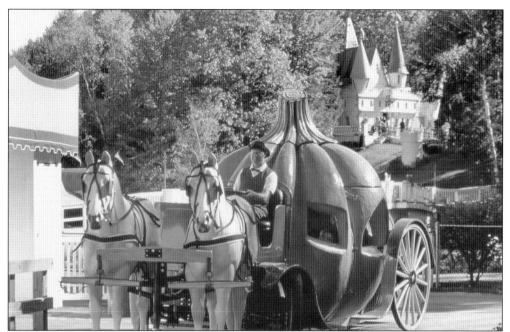

A third-generation Pumpkin Coach debuted at Cinderella's Castle in 2005 and became the primary carriage by 2007, when this photograph was taken. Like the two before it, this coach was built by Story Land staff and local contractors, including a heavy-duty chassis from Mountain Valley Fabrication of Conway, New Hampshire. The rechargeable battery-powered motor is silent and, unlike the first two coaches, there is a steering wheel instead of reins.

The Flying Fish became the third ride in Oceans of Fun in 2006. Although the park already owned a used version of the classic Flying Scooter from the defunct Whalom Park of Massachusetts, Story Land purchased and installed this version new from Larson International of Plainview, Texas, instead. The fish designs on the vehicles were created and painted by members of the Story Land art department.

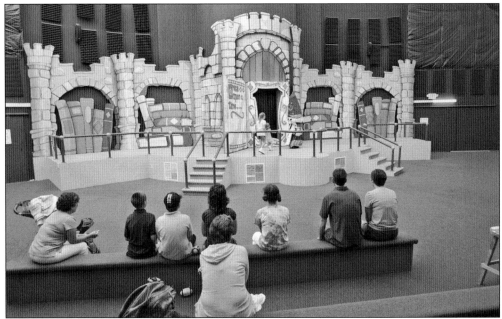

Story Land opened its 2008 season under the ownership of Kennywood Entertainment of West Mifflin, Pennsylvania, which had purchased the park from the Morrell family during the prior summer. Kennywood continued the park's practice of investing in new improvements for the summer of 2008. In the photograph above, Story Land staff converted the Loopy Lab theater and stage (page 111) into a setting for a new show produced by American Entertainment Productions of Columbus, Ohio. Kennywood also provided a used classic water game, completely refurbished by Story Land staff to match the Oceans of Fun theme for a building that replaced the deteriorated Sandcastle Maze (page 110).

In 2008, Story Land added a geyser-themed water play area outside of Dr. Geyser's Remarkable Raft Ride, primarily for children not yet quite tall enough to meet the ride's 36-inch height requirement. Consisting of multiple fountain heads below ground level that were choreographed by computer controls, the cooling jets proved popular with children of all sizes.

The major capital development project for 2008 was the completion of an area partially developed in 2003–2004 near the barnyard section. Building on Kennywood's history of working with circus owner and producer Struppi Hanneford, Story Land arranged for a season-long production of family-oriented acts by the Royal Hanneford Circus under one of its smaller big-top tents.

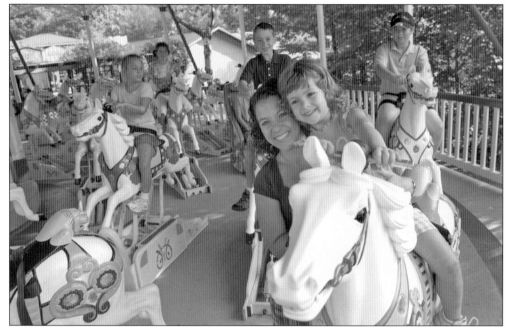

Story Land continued to blend preservation of timeless and simple values with new innovation, from the time of its inception in 1954 into a new century. Even as children in this 2008 photograph rode wooden "springer" horses hand-carved in the mid-1800s, the horses were freshly painted and rocked on new steel bases designed and built at Story Land in 2005 to replace century-old wooden bases (page 45).

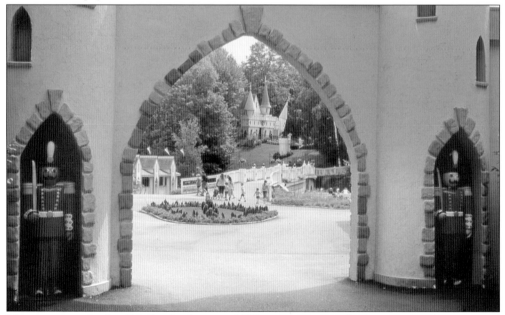

The gateway to Cinderella's Castle, shown in 2007, generates as much excitement and anticipation in the imaginative minds of children today as it did when it first appeared in the late 1950s (page 30). Over half a century of focus on families and commitment to value positioned Story Land for an exciting future of possibilities in the 21st century.

BIBLIOGRAPHY

Anderson, Alice Hellstrom. *Company Secrets*. Longwood, FL: Power Publications, Inc., 2004.
Landry, Linda. *Classic New Hampshire*. Lebanon, NH: University Press of New England, 2003.
Morrell, Robert S., and R. Stoning Morrell Jr. *Winds of Imagination*. Princeton, NJ: Princeton
 University Press, 1991.

www.arcadiapublishing.com

Discover books about the town where you grew up, the cities where your friends and families live, the town where your parents met, or even that retirement spot you've been dreaming about. Our Web site provides history lovers with exclusive deals, advanced notification about new titles, e-mail alerts of author events, and much more.

Arcadia Publishing, the leading local history publisher in the United States, is committed to making history accessible and meaningful through publishing books that celebrate and preserve the heritage of America's people and places. Consistent with our mission to preserve history on a local level, this book was printed in South Carolina on American-made paper and manufactured entirely in the United States.

This book carries the accredited Forest Stewardship Council (FSC) label and is printed on 100 percent FSC-certified paper. Products carrying the FSC label are independently certified to assure consumers that they come from forests that are managed to meet the social, economic, and ecological needs of present and future generations.

FSC
Mixed Sources
Product group from well-managed forests and other controlled sources

Cert no. SW-COC-001530
www.fsc.org
© 1996 Forest Stewardship Council

Find Your Place in History.